South Bronx Hall of Fame

Sculpture by

John Ahearn

and

Rigoberto Torres

Essays by

Richard Goldstein

Michael Ventura

Marilyn A. Zeitlin
Guest Curator

CONTEMPORARY ARTS MUSEUM, HOUSTON

South Bronx Hall of Fame:
Sculpture by John Ahearn and Rigoberto Torres
is supported by:

Lannan Foundation, Los Angeles

National Endowment for the Arts

Contemporary Arts Museum Major Exhibition Fund

Contemporary Arts Museum, Houston
14 September – 3 November 1991

Witte de With, Rotterdam
7 December 1991 – 26 January 1992

The Contemporary Arts Center, Cincinnati
14 February – 18 April 1992

The Contemporary Museum, Honolulu
10 June – 9 August 1992

Library of Congress Cataloging-in-Publication Data

Zeitlin, Marilyn.
 South Bronx Hall of Fame : sculpture by John Ahearn and
Rigoberto Torres : essays / by Marilyn A. Zeitlin, Michael
Ventura, Richard Goldstein.
 p. cm.
 Exhibition catalog.
 Includes bibliographical references.
 ISBN 0-936080-21-3 (pbk.)
 ISBN 90-73362-14-8 geb. (Dutch edition)
 1. Ahearn, John. 1951– –Exhibitions. 2. Torres,
Rigoberto– Exhibitions. 3. Group work in art–New York (N.Y.)
–Exhibitions. I. Ahearn, John, 1951– . II. Torres, Rigoberto.
III. Ventura, Michael. IV. Golstein, Richard, 1944– .
V. Contemporary Arts Museum. VI. Hall of Fame for Great
Americans. VII. Title.
NB237.A35A4 1991
730'.92–dc20 91-72303
 CIP

Distributed by
University of Washington Press
P.O. Box 50096
Seattle, Washington 98145-5096
1-800-441-4115

On occasion, the artists make different versions of a cast, such
as one for the model or one for a public wall mural, as well as
different casts of the same person. Bracketed figure numbers
[fig. no.] in captions refer to these variations.

cover:
John Ahearn and Rigoberto Torres
Back to School 1985 [fig. 92]
[left to right] *Maggie and Connie, Gibbie, Titi in Window, Kido
and Ralph,* and *Jay with Bike*
Walton Avenue at 170th Street, Bronx, New York

Different versions of *Maggie and Connie, Titi in Window,* and
Jay with Bike are included in the exhibition.

back cover:
Rigoberto Torres [left] and John Ahearn [right] casting Hazel
Santiago [fig. 133] at a Walton Avenue block party, September
1985.

frontispiece:
Installation of *We Are Family,* 1982, Fox Street at Intervale
Avenue, Bronx. On scaffold: Rigoberto Torres [top] and John
Ahearn [bottom] hoisting *Layman.*

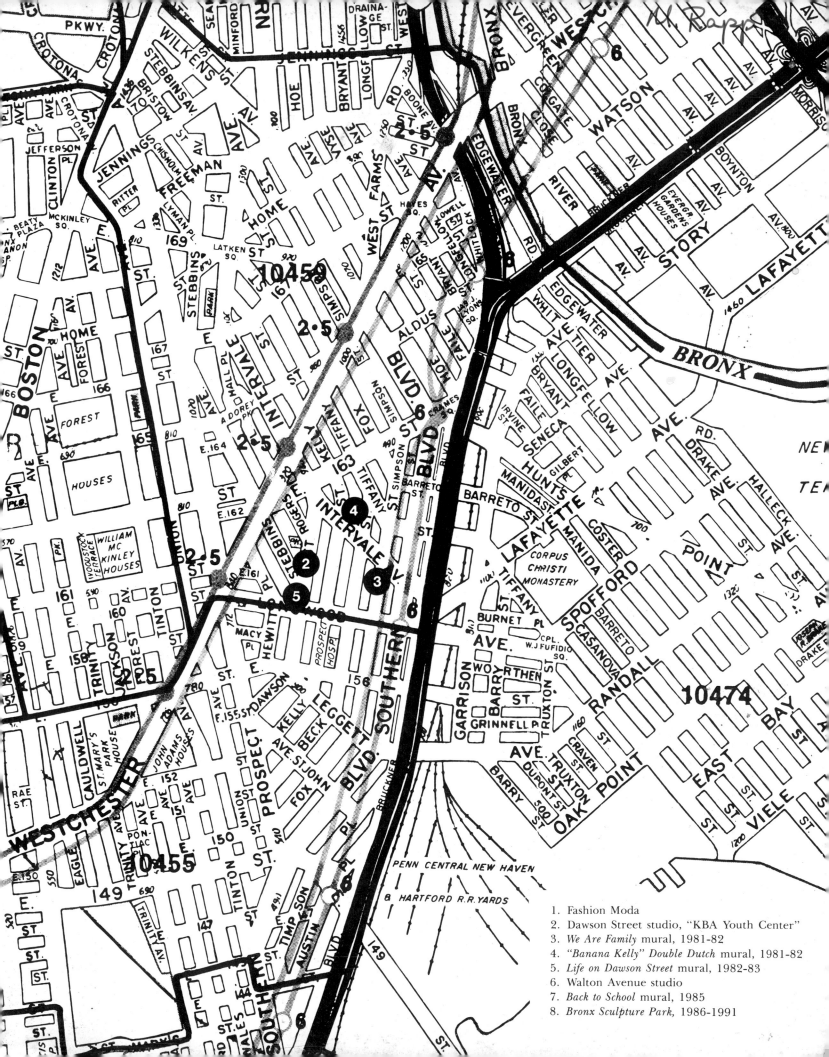

1. Fashion Moda
2. Dawson Street studio, "KBA Youth Center"
3. *We Are Family* mural, 1981-82
4. *"Banana Kelly" Double Dutch* mural, 1981-82
5. *Life on Dawson Street* mural, 1982-83
6. Walton Avenue studio
7. *Back to School* mural, 1985
8. *Bronx Sculpture Park*, 1986-1991

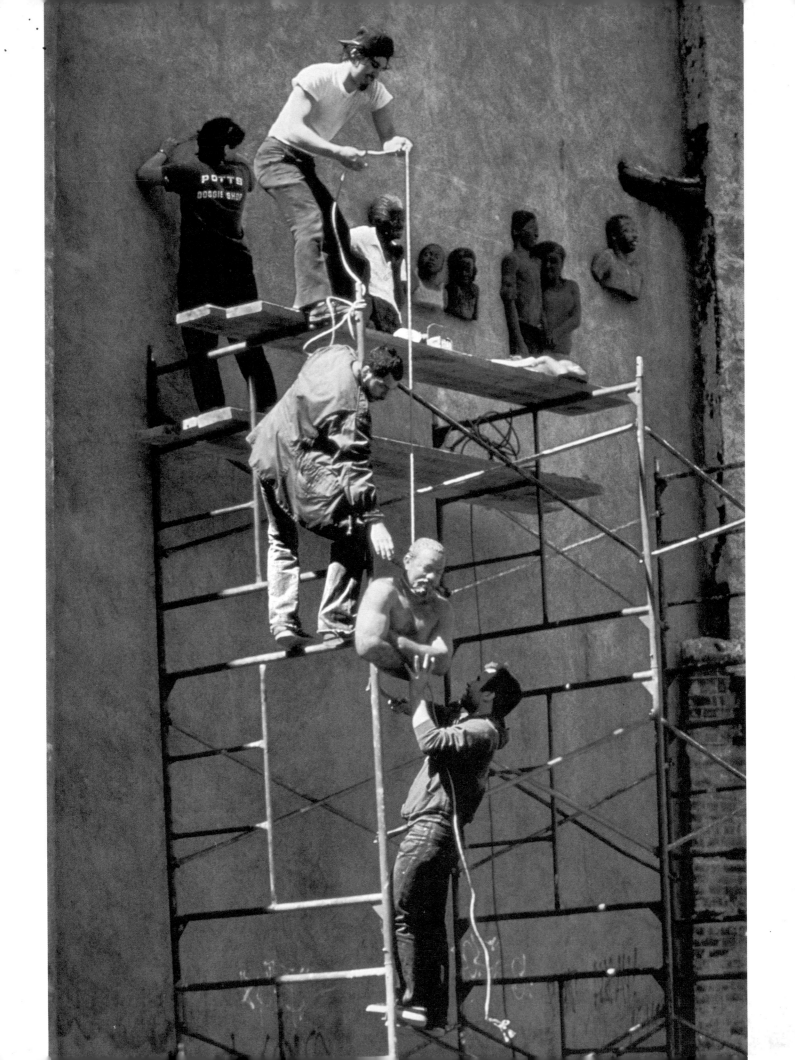

Contents

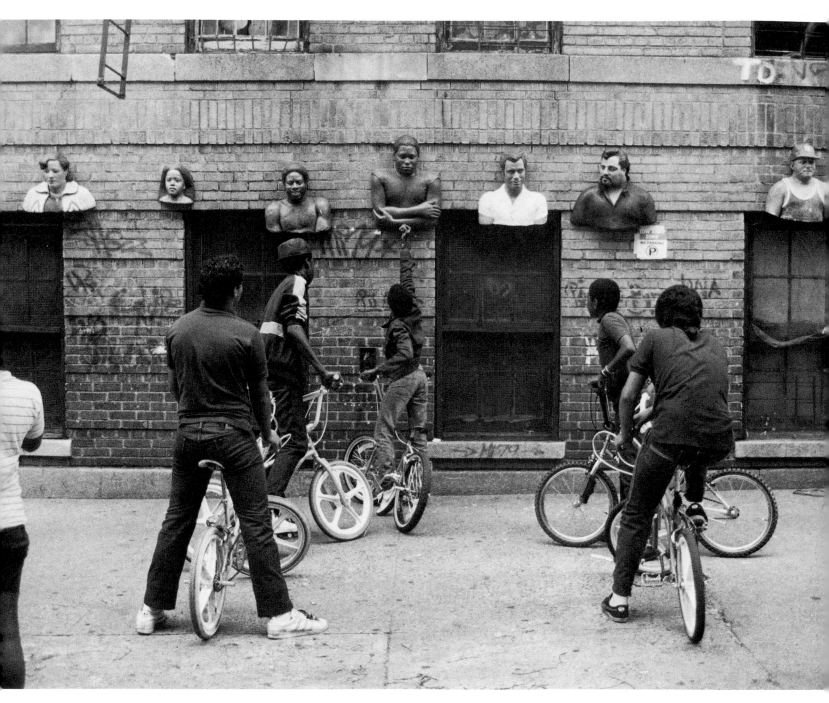

1. Walton Avenue block party for inauguration of *Back to School* mural, 1985. Finished casts are often hung on the studio building during block parties and public castings; [left to right by Ahearn except noted] *Connie* and *Maggie* [fig. 91], *Amando, Corey* [fig. 101], Torres' cast of Ahearn, *Veldez,* and *Tony* [fig. 80].

Foreword and Acknowledgments

This exhibition celebrates the body of work John Ahearn has made in collaboration with Rigoberto Torres since 1979 when they met at Fashion Moda, an alternative space in the sprawling borough of the Bronx, about ten miles away from the dense concentration of commercial galleries and highly prized artists' lofts in Tribeca and Soho in lower Manhattan. Ahearn was attracted to Fashion Moda because he, like a handful of other pioneering artists of his generation, sought to break from the art establishment to reclaim for art a place in the fabric of daily life and to renew the ancient role of the artist in society. Torres came to Fashion Moda from another point. As a longtime resident of the South Bronx, he was encouraged to visit the storefront art center by family members eager to reinforce his talent for making things. Ahearn's training in art began at Cornell University's School of Architecture, where he studied painting, which led him in the years immediately following his graduation to filmmaking in Manhattan's "downtown." It was the process of molding masks and disguises for film characters that turned him to casting sculptures of his artist friends in the late seventies. In Torres' case, he learned to make sculptural casts in his uncle's religious statuary factory in the South Bronx.

Although Ahearn and Torres came to Fashion Moda from different directions, both men were committed not only to making sculpture but to knowing more about one another's worlds. Ahearn was linked to the art world. Torres' sphere was his own tightly knit family and the black and Hispanic neighborhood around Walton Avenue where his parents settled when they immigrated to the United States from Puerto Rico. The camaraderie of working collaboratively also suited them both. Ahearn, a twin, liked the teamwork of performance and film; Torres, ten years younger, enjoyed the give and take of the craftsmen whom he worked with in his uncle's factory. Ahearn brought a broader scope of artistic knowledge to the partnership. Torres, streetwise and bilingual, smoothed the way, in turn, for Ahearn's acceptance in a community where, being white, he was an outsider: the other.

Soon after they joined forces to cast portraits of the men and women from the neighborhood around Fashion Moda, Ahearn mounted a show of their work and called it the *South Bronx Hall of Fame*. Years later, in another part of the borough, Ahearn discovered the Hall of Fame of Great Americans. He was amused by the ironic parallel between the title of his first exhibition with Torres and this grand public monument from the turn of the century. Designed by the acclaimed American architect Stanford White, with a procession of classical portrait busts of distinguished citizens by the leading sculptors of the period, this once-august monument captured the newly found industrial power and utopian aspirations of the United States in the opening years of the twentieth century.

Nearly a hundred years later on the eve of a new century, Ahearn and Torres have embued the age-old and venerable traditions of public art and portraiture with fresh vigor and timely significance. They have chosen to represent citizens who by tradition have not been memorialized in art nor given pride of place in our nation's public monuments and museums.

Like the French avant-garde artists in the mid-nineteenth century (Gustave Courbet, Honoré Daumier, and Edgar Degas, who shocked the art academy and public of their own day by portraying stonecutters and street entertainers rather than figures from history and classical mythology), Ahearn and Torres have made representations of their black and Hispanic neighbors. Through their empathy and art, they have revealed the heroic dimension of people from everyday walks of life and, in some cases, the downtrodden who have been largely bypassed in the creation and interpretation of art.

In a wider sense, they have recorded the changing nature of the American public a decade before newspapers began carrying headlines about the tremendous shifts in the demographics of the United States. While charting new subjects and contexts for art, Ahearn and Torres have in their own singular way done what we have always needed artists to do: they have been first to perceive and give form to the changing world around us.

The Contemporary Arts Museum is pleased to present this first comprehensive survey of Ahearn and Torres' work and to offer a wider public an overview of their sculpture, which is both universal in its humanism and particular to the time and place in which it was made. For this reason, the exhibition and publication are organized around the four neighborhood locations where Torres and Ahearn have worked collaboratively as well as independently in the past decade: Fashion Moda, 1979; Walton Avenue, 1980–81; Dawson Street, 1981–83; and Walton Avenue, 1983–91.

We are truly grateful to Marilyn A. Zeitlin, guest curator, for organizing the exhibition, which she conceived five years ago during her tenure as director of the Anderson Gallery of Virginia Commonwealth University. The exhibition was developed while Zeitlin was curator of the Contemporary Arts Museum and finished from her post as executive director of the Washington Project for the Arts.

The community spirit of the art has also shaped and enriched the project in the process of its realization. The enthusiastic commitment of Chris Dercon, director of Witte de With in Rotterdam, and the enlightened multicultural policies of the City of Rotterdam and the Rotterdam Arts Council launched the international tour of the exhibition. We are grateful to Dennis Barrie, director of The Contemporary Arts Center in Cincinnati, and James Jensen, associate director of The Contemporary Museum in Honolulu, for their appreciation of Ahearn and Torres' art; we are delighted the exhibition will be seen in these different parts of the United States. We are grateful to the State Foundation on Culture and the Arts and *The Honolulu Advertiser* for insuring the success of the exhibition for audiences in Hawaii.

In Houston, Lynn Herbert, CAM's assistant curator, managed the exhibition and publication with her keen understanding of the artists' intentions and the interpretation of their art for wider audiences. All aspects of the project have been enhanced by her high level of professionalism and unflappable good humor.

The arrangements for packing and transport were handled with sensitivity and thoroughness by Jill L. Newmark, the Museum's registrar. Michael Reed, CAM's museum manager, brought his fine sense of planning and design to the exhibition installation. Ellen Efsic, curatorial assistant, carried out research and handled all of the correspondence for the exhibition and tour with care, seeming ease, and elegant good cheer.

In Washington, Christine Hoepfner from the WPA staff ably assisted Marilyn A. Zeitlin with communications and correspondence. In New York, the project benefited from the gracious and ready assistance of Brooke and Carolyn Alexander of Brooke Alexander, Inc., and Ted Bonin, the gallery director. Catherine Tompkins of the gallery's staff provided invaluable archival information. To each our heartfelt appreciation.

The publication, which we hope will be a lasting document of Ahearn and Torres' first major museum exhibition, reflects the thoroughness and commitment of many individuals. We are enormously grateful to Richard Goldstein, Michael Ventura, and Marilyn A. Zeitlin for their insightful essays, which view Ahearn and Torres' collaboration from different perspectives. Richard Goldstein has covered art, popular culture, and politics for twenty-five years for *The Village Voice*, where he is executive editor, as well as for such publications as *The New York Times* and *Artforum*. He is the author of *Reporting the Counterculture*, a collection of journalism on the art and politics of the sixties published by Unwin Hyman in 1990, and "A Disease of Society," included in *The Implicated and the Immune: Cultural Responses to AIDS* issued by Cambridge University Press in 1990. Michael Ventura, who grew up in the South Bronx, has been writing for the *L.A. Weekly* since

1979. J.P. Thacher published his *Shadow Dancing in the U.S.A.*, a collection of essays, in 1985, and his novel *Night Time Losing Time* was published by Simon & Schuster in 1989. Marilyn A. Zeitlin is an art historian.

Lynn Herbert served as the publication's overall editor. She also wrote the captions in association with John Ahearn. Suzanne Root, intern from Connecticut College, helped to prepare the bibliography. Polly Koch, a Houston-based writer, refined all the manuscripts with hawk-eyed precision. From Washington, Lynn Schmidt advised Marilyn A. Zeitlin on her text. To make the publication accessible to audiences in The Netherlands, Chris Dercon and Mat Verberkt from Witte de With have translated the key essays into Dutch for 750 copies of the edition.

My special thanks to Don Quaintance of Public Address Design in Houston for the handsome design of the publication and his thoughtful graphic interpretation of the artists' collaboration with the community in which they live and work. The illustrations represent the work of a good number of photographers cited on page 111; we would particularly like to acknowledge Ivan Dalla Tana for taking the photograph for the publication's cover and for granting us permission to reproduce the photographs of the models in their homes with their own portraits by the artists. These images help to convey the lively social context that is at the center of Ahearn and Torres' creative enterprise.

In addition to the catalogue, CAM also commissioned a videotape in English and Spanish to extend the documentation of the artists' work. It was produced by Bill Howze of Documentary Arts, Houston. NBC kindly made footage from its archives available for us, as did Charlie Ahearn, the twin brother of the sculptor.

All special exhibitions—particularly those that tour—are absolutely dependent on the generosity of lenders. It is a tribute to Ahearn and to Torres that the individuals and institutions listed on page 10 were willing to part with such fragile and much-treasured works for nearly a year. I would like to extend my personal thanks to each and every lender for their willingness to share these works with audiences stretching from the Atlantic to the Pacific, insuring that the artists' sense of community spreads far beyond the boundaries of the South Bronx.

The CAM trustees have been admirable in their support of this exhibition and publication. I am enormously grateful to all of them. We extend our special appreciation to the 1990–91 donors to CAM's Major Exhibition Fund acknowledged on page 10 for their crucial patronage and adventurous commitment to the Museum's mission to present the art of our own time to the public. We are also indebted to the Lannan Foundation, Los Angeles, under the direction of Lisa Lyons, for its grant to fund the exhibition, publication, and international tour. Quite simply, the exhibition could not have happened without the Lannan's support.

All good projects require a leap of faith. All of us at CAM are thankful for the National Endowment for the Arts, a federal agency, for its early grant. It was the critical seed money that allowed us to make Marilyn A. Zeitlin's concept evolve into a tangible reality.

John Ahearn has been an enthusiastic and ready collaborator in bringing the exhibition and publication to fruition. He graciously welcomed us to his neighborhood and showed us his and Torres' various studios and public projects. During the past two years, he has readily answered letters and calls and tracked down photographs with great thoroughness. We are truly grateful to him and to Rigoberto Torres for their full cooperation and the great pleasure of realizing this project.

Suzanne Delehanty, *Director*
Contemporary Arts Museum, Houston

1990–1991 CAM Major Exhibition Fund Donors

Mrs. E. Rudge Allen

Mr. and Mrs. A. L. Ballard

The Brown Foundation, Inc.

Mr. and Mrs. James A. Elkins, Jr.

The Charles Engelhard Foundation

George and Mary Josephine Hamman Foundation

Mr. and Mrs. I. H. Kempner III

Mr. and Mrs. Meredith J. Long

Mr. and Mrs. Harris Masterson III

Fayez Sarofim & Company

Louisa Stude Sarofim

Eric H. Scheffey, M.D.

Lenders to the Exhibition

John Ahearn, *Bronx, New York*

Brooke and Carolyn Alexander, *New York*

Brooke Alexander, Inc., *New York*

The Eli Broad Family Foundation,
 Santa Monica, California

The Brooklyn Museum, *Brooklyn, New York*

The Chase Manhattan Bank, N.A., *New York*

Edward R. Downe, Jr., *New York*

Froma Eisenberg, *New York*

The Foundation to Life, Inc., *New York*

Kempf Hogan, *Birmingham, Michigan*

The Honolulu Advertiser Collection, *Honolulu*

Lannan Foundation, *Los Angeles*

Mr. and Mrs. Herbert Levitt, *Short Hills, New Jersey*

Susan and Lewis Manilow, *Chicago*

The Metropolitan Museum of Art, *New York*

Milwaukee Art Museum, *Milwaukee, Wisconsin*

The Museum of Contemporary Art, *Los Angeles*

Munira Nusseibeh and Francisco Hernandez,
 New York

Tom Otterness, *New York*

William and Norma Roth, *Winter Haven, Florida*

Rubell Family Collection, *New York*

Rigoberto Torres, *Bronx, New York*

University of South Florida, *Tampa*

Cheryl and Henry Welt, *New York*

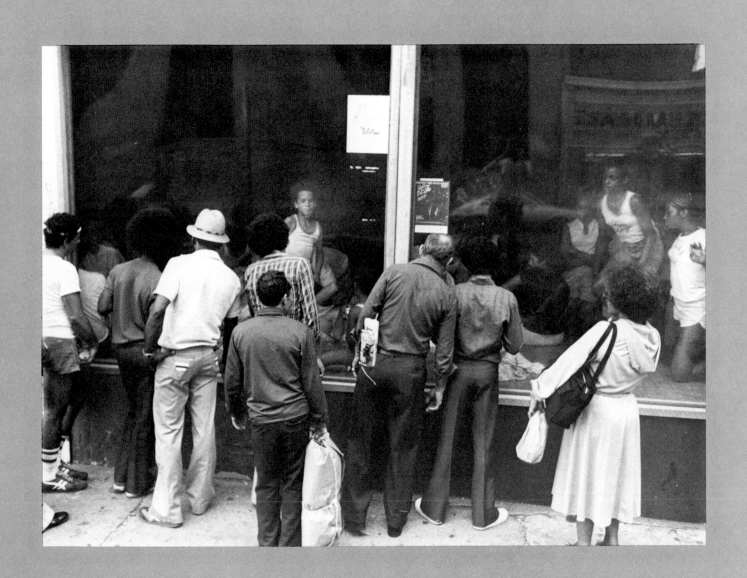

1979

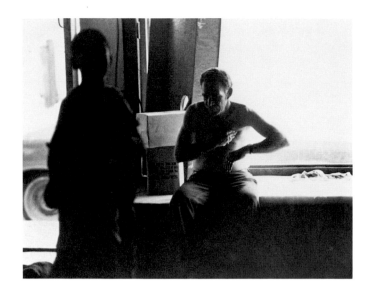

 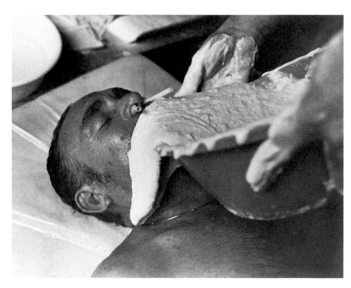

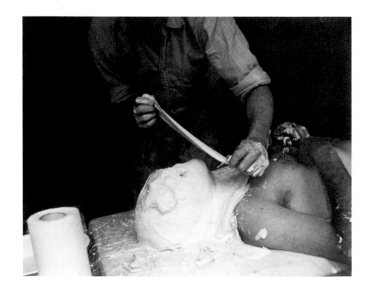

page 11:
2. Crowd watching the casting of *Carlos* through the storefront window of Fashion Moda, July 1979. All the casts from the Fashion Moda period were made in this setting. This series of photographs [figs. 2–11] was taken by Christof Kohlhofer.

3–7. Casting *Carlos* at Fashion Moda, July 1979.

opposite:
8. Torres [left, in white undershirt] and Ahearn [center] during casting of *Carlos*, with Fashion Moda co-directors, Stefan Eins and Joe Lewis [standing background, left to right], Fashion Moda, July 1979.

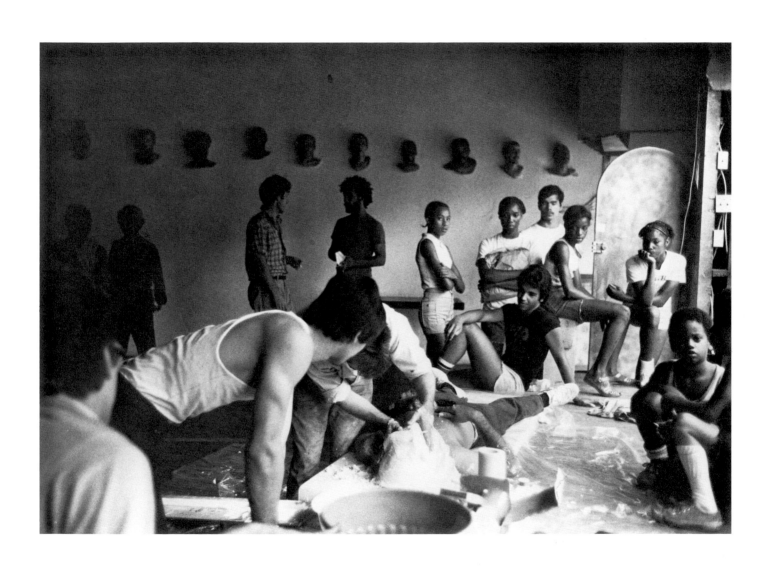

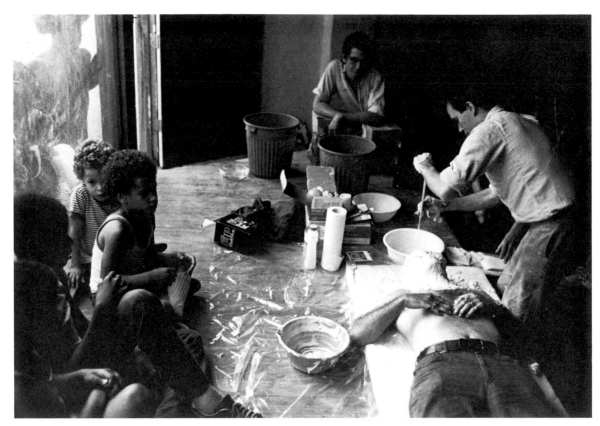

9. Tom Otterness [background, center] watching Ahearn cast *Carlos*, Fashion Moda, July 1979.

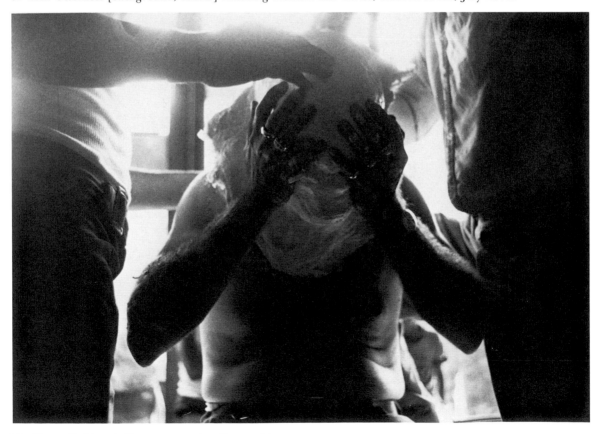

10. Torres [left] and Ahearn removing face mold.

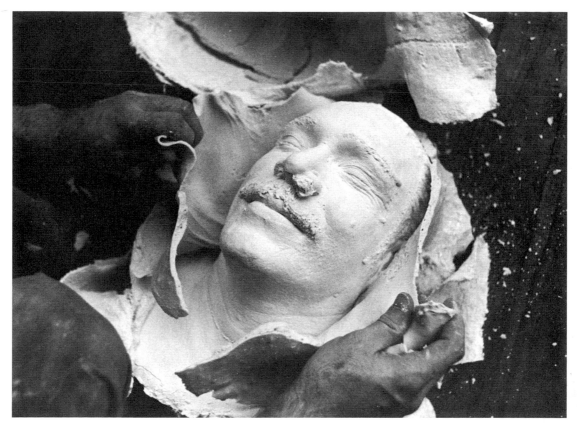

11. Removing mold from plaster cast of *Carlos*.

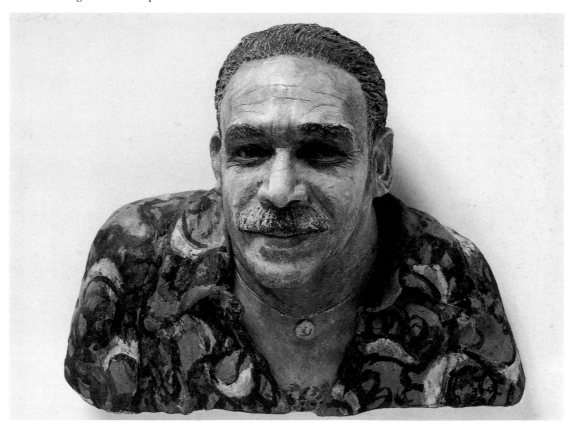

12. John Ahearn, *Carlos* 1979, Collection Lannan Foundation, Los Angeles.

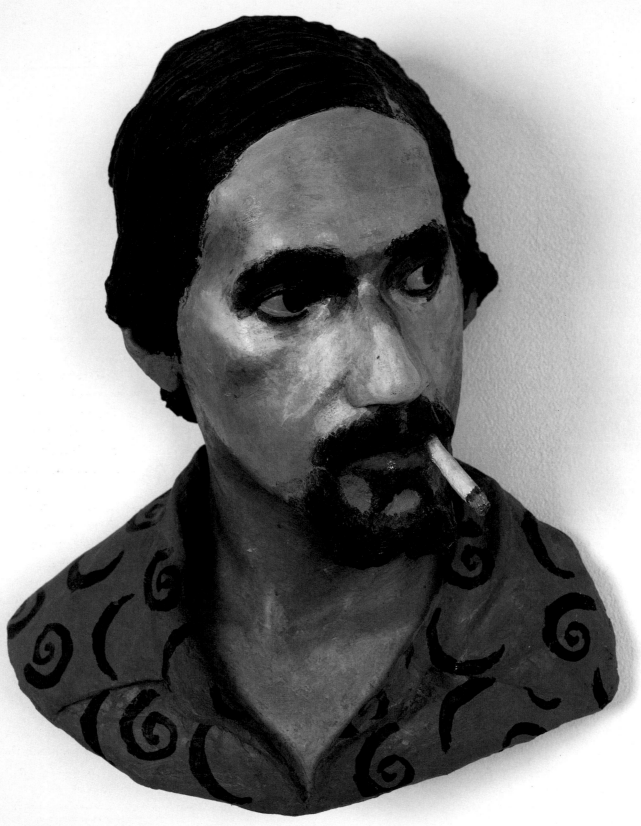

13. John Ahearn
Johnny 1979
Collection the artist

"Take counsel here of wisdom, beauty, power..."

MARILYN A. ZEITLIN

Ideas that now comprise a major thrust in the agenda of cultural institutions from alternative spaces to The Metropolitan Museum of Art are challenging traditional boundaries of culture. The expansion of the mainstream to include the contributions of people who have long been marginalized—African-American, Asian-American, Native American, and Latino—now goes beyond the tokenism that earlier accepted a handful of artists of color whose intuitive sensibility may have been schooled out of them. Multiculturalism, as this initiative is called, is more than a few exotic works in a permanent collection. It is more than an infusion of new imagery to make the mainstream more interesting. It is nothing less than the cultural frontier of the Civil Rights Movement.

John Ahearn and Rigoberto Torres are artists who live and work in the South Bronx. It is a neighborhood that existed long before "multiculturalism," and it will be there long after the focus of the curators of culture shifts to other concerns. But the interaction of these two artists with the people of the neighborhood over the past thirteen years serves as a model for new multicultural ventures taking shape along this frontier.

John Ahearn began to work in the South Bronx in 1979 as part of the action at Fashion Moda. That action was characteristic of the late seventies, the heyday of alternative artist-run art centers where experimentation and grass roots involvement were priorities. The first sculptural work that Ahearn showed there were casts of Manhattan art world friends that he had made downtown. At Fashion Moda, Ahearn began to cast people that lived nearby. Rigoberto Torres is one of the people he met and cast. Soon after, Torres began to work with Ahearn. It was Torres' idea to cast people from the South Bronx's Walton Avenue neighborhood in which he lived (figs. 13–19, 21–23, 25–27, 34).

On a March day in 1989, I went to visit the artists in the South Bronx and to watch them make a cast. I rode the elevated subway train that arches high over the Harlem River that separates Manhattan from the South Bronx. As the train rattled to a stop at 161st Street, I remembered riding the El to Yankee Stadium, an outing that was a high point of my childhood summers. In addition to the anticipation of seeing the game, I had taken a secret pleasure in looking furtively into windows of the huge apartment blocks at the level of the train to grasp an image of people's lives as we sped by, each one like a single frame of a movie.

On the day that I watched a casting out in front of the building on Walton Avenue, the artists had borrowed statues from people on the block who had been cast before and hung their portrait busts from nails on the building facade. Everyone on the block knew what that signaled. As the young girl to be cast climbed onto the folding table set up on the sidewalk, I was reminded for a moment of the daredevil who volunteers to be cut in half by a stage magician. The girl's mother and aunt loomed over her; others crowded in close to see, to heckle

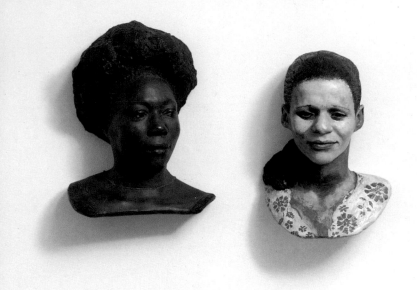

a little, or to ask that they, too, be models.

The casting process happens in a very public way, a minor fiesta (figs. 2–12, 20). The event usually occurs out on the sidewalk in front of friends, family, and neighbors. Everyone knows everyone else. The moment is loaded. Swathed in plaster bandages covering parts of the body and the entire face, the model risks ridicule if he or she cannot tolerate the discomfort or fear, and the artists would face big trouble if the model, especially a child, were to panic. It is an act of bravery and of trust.

Ahearn talked to the model as they worked, telling her how to place her hands, keeping up an even stream of familiar references, touching her reassuringly as molding gel was applied to her body. Torres put straws in the girl's nose as the gel reached her face. Then the two artists took soaked surgical plaster bandages and wrapped them around and over her body. For a moment, as the plaster was setting, she was a mysterious white bundle, a mummy. The artists are reluctant to cast children who are too young, for fear they might panic, but part of the desire to be cast is to

14–19. John Ahearn
[left to right] *Janice Parsons, Pregnant Girl, Greek Head, Sandy, Butch and Earl,* and *Big City* 1979
Collection the artist

demonstrate bravery before the crowd. The entire operation took hardly twenty minutes. As they removed the plaster mold, Ahearn said, yes, it was a good cast, and Torres nodded in agreement.

Street-side castings began at Fashion Moda, where the artists first cast people from the neighborhood, many from the methadone clinic across the street. After they hung a few pieces— casts of people known in the neighborhood— word would go out that a new sculpture was being shown. People who came to look wanted to know how they could get one. Soon the line formed.

Fashion Moda brought more than contemporary art to the neighborhood. Artists who wanted a place free of the restraints that the art market imposes could try things out there, take a risk. Much of the work they did drew its energy from the street, a strong presence in the South Bronx. Joe Lewis, a co-director of Fashion Moda with founder Stefan Eins, says, "It was an outlet for the disenfranchised, a Salon des Refusés that cut across the uptown/downtown dichotomy, across the black/white/Hispanic isolation."[1] The idea was not to try to change the habits of the people but to change the concept of an art space from excluding walls to an open arena for use by the community. People in the South Bronx live within narrow boundaries and rarely venture far from

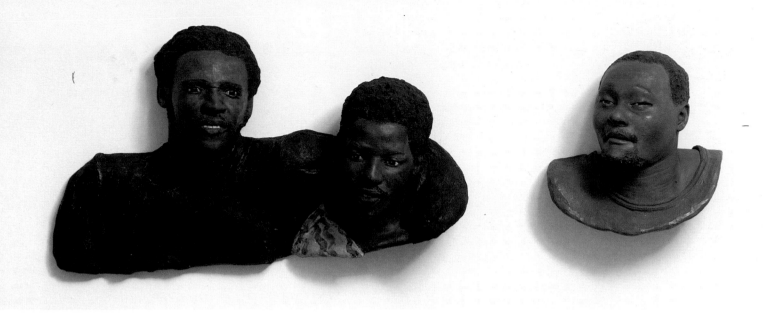

their usual routes. They encountered Fashion Moda only because it was right on the sidewalk that led from their shopping street to the projects. First they just looked in the window. Gradually they came in and became a part of the process. The work culminated in the original Fashion Moda *South Bronx Hall of Fame* show (fig. 35).

Collaborative Projects, Inc. (Colab), another experiment in which artists retained control of the presentation of their work, happened almost concurrently with Fashion Moda, evolving downtown and involving many of the same Manhattan artists. Colab's most ambitious project was the *Times Square Show* (fig. 24). In June of 1980, Ahearn and the other organizing coordinators convinced the owner of an abandoned massage parlor in Times Square (Broadway and West 42nd Street) to give Colab use of the building for a returnable $500 security deposit, providing that they replace the windows. The exhibition was in part a lark and in part a spoof of manifestos, gallery collectors' nights, and other standard marketing strategies of commercial art galleries.

Almost in spite of itself, the *Times Square Show* succeeded in introducing a number of artists to the mainstream art world. Like Pop Art before it, the *Times Square Show* had claimed, even if inadvertently, new territory in the media and the

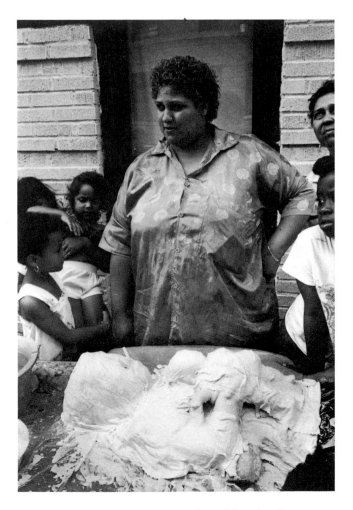

20. Jackie Nunez watches the casting of her daughter Zuhey Perallon, Walton Avenue, summer 1990.

19

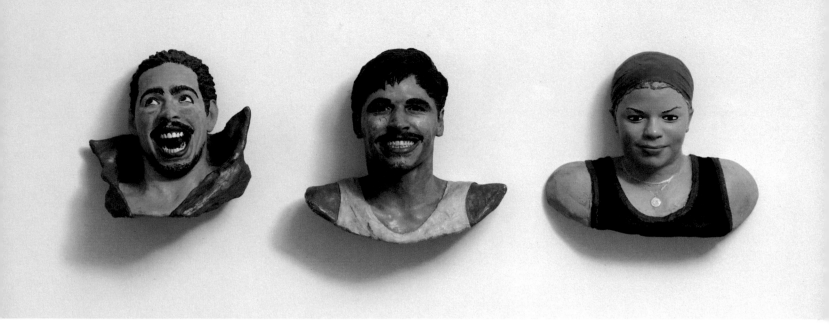

21 & 22. John Ahearn
[left] *David Ortiz (laughing)* and [center] *Robert* [Rigoberto Torres] 1979
Collection the artist

23. Rigoberto Torres
[right] *Shirley* 1979
Collection John Ahearn

opposite:
25–27. John Ahearn
[left to right] *Willy Neal, Mario and Norma,* and *David (with scar)* 1979
Collection the artist

24. Installation view of "Portrait Room" of *Times Square Show,* 1980: [clockwise from bottom far left] *Octopus Window,* Rebecca Howland; *Life Casts from the South Bronx,* John Ahearn; *Untitled,* two photographs, Jules Allen; *CODL Cowboy,* David Wells; *Mirror Portrait,* Meryle; *Homeless Women,* Anne-Marie Rosseau; *Lead Suit for Nuclear Age,* Tom Otterness.

market. Collectors were no longer exclusively the patrician supporters of the avant-garde art of abstract expressionism or of the movements like minimalism that succeeded it. As Pop Art was an antidote to the vitiated abstract expressionism of the 1960s, the cool geometry of the late sixties minimalism was a response to the sardonic social and art critique of Pop. The *Times Square Show* offered something that had been lost in the repetition and high-revved marketing of late Pop: it was outrageous, it was fresh, and it was fun.

The freewheeling venture brought people together from many quarters, including the Studio Museum in Harlem, the medical workers' union Bread and Roses, Printed Matter, and Artists Space. The show spilled through the seedy building, seeping into the basement, skidding through stairwells. It was exciting, with a sense of abandon, humor, and an edge of danger. Performances were presented nightly, starting at midnight. One night, Torres and Ahearn cast the night watchman (fig. 33). Artists slept there, opening the show the next morning when they awoke. Several press releases were issued, some parodies of the standard institutional lingo. It stole both popular media and art coverage.

Important people in the art world came, art dealer Brooke Alexander among them. He says

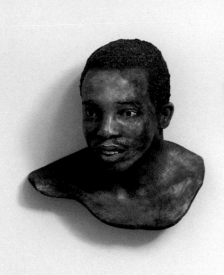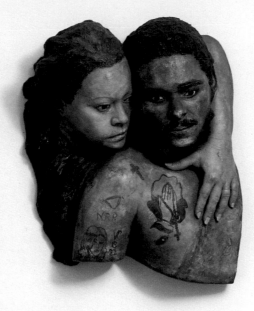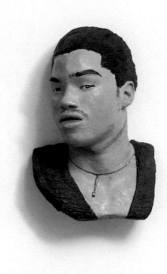

he was astonished by it. He first saw Ahearn's work there and asked if he could buy some pieces. Ahearn refused, concerned that showing the work in a gallery might destroy the delicate relationships he was building among the people he worked with in the Bronx. Several months after the *Times Square Show*, Ahearn did consent to show in a group exhibition at Brooke Alexander gallery, and three years later he had his first solo exhibition there.

Alexander recalls, "He picked an odd time. He didn't want to necessarily show when everyone else was showing. He did a show in July and then was a little bit surprised when no one was there. It was a typical John contradiction."[2]

Besides fearing that exposure of the work in the art world would disturb the balance in the Bronx, Ahearn was sensitive to the issue of exploitation. "That's part of the package," Ahearn says. "You can't be involved with working with people without exploitation being a potential consideration. To attempt to be pure is like playing a game that you can never win. You could say that Mondrian never exploited people, but the more you are involved with people, the greater the risk of exploitation."[3]

Had he sought to exert his own ego in a way that offended people in the neighborhood, not only would he have failed in making art with their participation, but he might have loosed a

dangerous reaction. As an outsider, he was sized up by people whose streetwise instincts in detecting a con are honed by long experience. Joe Lewis says that people read Ahearn's motivation correctly: "He is committed to sharing his experience with people. What he gives back to the people he lives with is encouragement to reach for their goals."[4]

Shortly after the *Times Square Show*, Ahearn moved to Walton Avenue, into the building where Torres and his family lived. Raymond Garcia, the young man crouched beside his pit bull in *Raymond and Toby* (fig. 98), tells how people reacted when Ahearn moved in. "At that time, nearly all the white people had left. There were maybe two, three white families left. Then here comes John and we think, uh oh, here they come again."[5]

Garcia has been close to the center of the artists' project. He and Ahearn have been in nearly daily contact for years. Nearly everyone in the Garcia family has been cast: *Freddy* (fig. 109), *Car Painter* (fig. 94), and *Titi Concha* (fig. 114) all are Garcia's relatives. The mortality rate has been very high in this family, with many deaths from AIDS.

Garcia talks about the arrival of crack on the block. When a strain of cocaine hit the street that was so strong it was killing people, users tried crack because they thought it was less lethal. "Not even the politicians knew what crack would do," he tells us.[6]

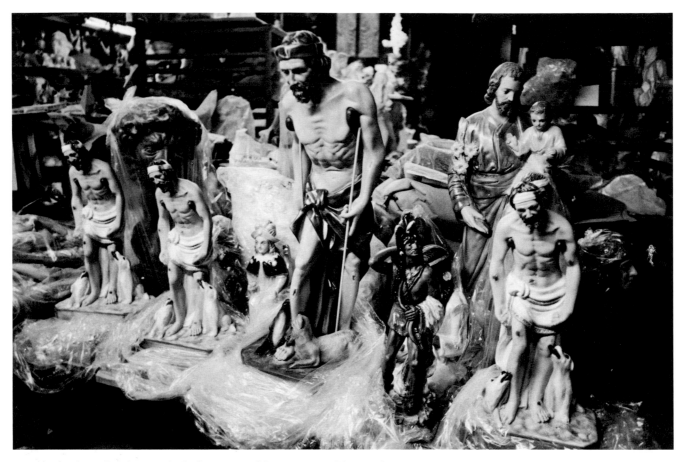

28. A selection of sculptures including casts of St. Lazaro [with crutches] at Paul's Statuary Co. [formerly C & R Statuary Corporation], Bronx, 1991.

Sometimes the relationship between Garcia and Ahearn takes a crazy turn, reflecting the tension and violence that lies just beneath the surface in the neighborhood. Garcia once broke into Ahearn's apartment. Ahearn was out, so he helped himself to a bowl of cereal then called the police to turn himself in. He told the police that he had robbed and killed Ahearn. Garcia recalls the incident as a prank. Ahearn remembers the horror that his twin brother Charlie experienced when the police called him in search of Ahearn.

Despite the banality of tragedy and violence in the neighborhood, the artists more frequently discover dignity, elegance, and humor in their models. Torres' uncle Raul Arce owns a factory in the Bronx that manufactures plaster figurines. His biggest sellers are the plaster saints of *santéria* that are sold to the *botanicas* in New York and New Jersey. The factory is filled with shelf after shelf of images of the Niño de Atocha, Lazaro,

Nuestra Señora de Merced, Elize, the *voudon* goddess of love, and black Madonnas holding white baby Jesuses, but also Michelangelo's *David*, bowls of fruit, naked putti, and piggy banks (fig. 28). Arce is a master mold-maker, a skill that both his nephew and Ahearn emulate. One of Torres' finest works depicts *Shorty Working in the C & R Statuary Corporation* (fig. 67).

Ahearn points out the importance of Arce's factory in his own work. Raised a Catholic and still respectful of faith and the role the church can play, Ahearn in a sense makes plaster saints of his own. He takes the people of the mundane world of the South Bronx and allows the work to reveal them. At moments, he seems to show us their divinity.

Ahearn's *Lazaro* (fig. 110) explicitly evokes the patron saint of the most downtrodden, a figure popular among the people in the neighborhood. The traditional image of the saint shows a man in rags on crutches, dogs licking his bleeding legs.

Ahearn's model was a young man who had been living in an abandoned building, deeply entangled with drugs and inevitably getting into trouble with neighbors and police. One night, the violence underlying his life erupted and he was thrown from the roof of a building. Almost miraculously, he survived.

The sculpture *Lazaro* has a face distorted by swelling, casts on each arm, and a hospital gown drawn down to show his wounds. The gown constricts his arms to his side, as if police might have pulled it down to restrain him. The undress implies captivity, the flagellation of Christ, even rape. *Lazaro* stands like a saint in orrance, his expression stunned, his hands facing forward, imploring.

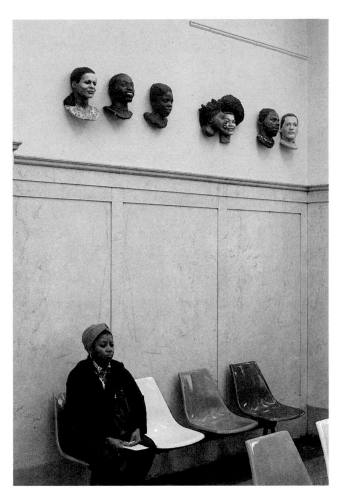

30. Installation of Fashion Moda heads at Con Edison waiting room, Bronx, November 1979.

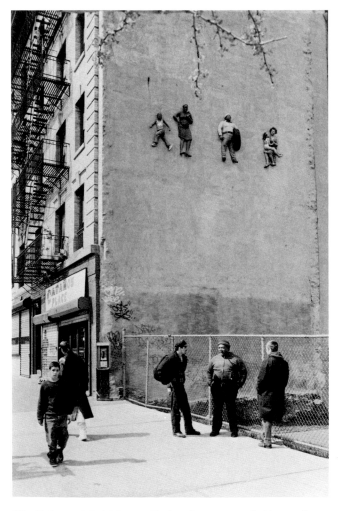

29. [left to right] Torres, Pedro Serrano, and Ahearn by fence under *Life on Dawson Street*, 1982–83, Longwood Avenue at Dawson Street, Bronx, April 1991.

Other figures emulate saints with their signature props. The stately *Pedro with Tire* (fig. 71) from the mural *Life on Dawson Street* (figs. 29, 75) recalls an Egyptian god-king or a Mayan holy prince or Moses. Pedro Serrano is a car mechanic. On the day that I met him, he was working with some buddies in the street below the mural that has his statue as its central image, tinkering under the hood of a Jeep. He was clearly in charge. He was pleased if a bit skeptical when told that his statue was my favorite. The man was every bit the digni-fied personage that I had admired through the art.

In a less explicit reference to religious sculpture, the figure *ElloRee* (fig. 100) wears a dress that falls in folds like a fluted column or like the saints integrated into cathedrals as engaged pilasters. Among the pairs of figures Ahearn has portrayed,

many are mother and daughter or woman and girl-child. *Pat and Selena at Play* (fig. 75), from the same mural as *Pedro with Tire*, shows a beautiful young woman with a girl on her lap, the image reminiscent of a stylish Gothic Madonna and Child.

Ahearn and Torres have cast a pantheon of young girls on the cusp of adulthood. *Bernice* (fig. 39), *Esther (in the sixth grade)* (fig. 46), and *Girl with Red Halter Top* (fig. 57) are firebrands. Esther strikes an aggressive hipshot pose, but her expression is apprehensive. Many of the young women on the street hover between the sensuality and swagger of being a tough number and the last vestiges of childhood vulnerability. The rites of passage in their world are treacherous. The work captures their fleeting innocence as it is overtaken by newfound sexual power.

Ahearn describes Takiya, a model from a recent work (fig. 122): "She is on an edge—proud, angry, defiant. You could say she has an attitude. I tried casting her and couldn't get it the first time. She didn't like it, told me I was no good. She trusted Stefan, a boy in the neighborhood (fig. 113), so I asked him to be my assistant on this job. We went shopping and found a fluorescent orange sweatshirt she liked. She could keep it after the casting. We were both satisfied with this second cast, though later I painted the shirt lime yellow because it set off her skin color better." [7]

In the first years on Walton Avenue, Ahearn and Torres' work grew in scale from the faces in the original *South Bronx Hall of Fame* show at Fashion Moda, to busts, to half-figures. Then in 1981, they were invited to do a mural in another part of the South Bronx. Contacted by one community association, they mistakenly went to talk the project over with another association on the same street. So they did two murals, and finally a third.

Dawson Street is a tougher neighborhood than Walton Avenue, with a different cultural base. The people on Walton are primarily Puerto Rican with black families at the north end of the block. On Dawson almost all the people are black, even poorer than the families on Walton. Though many of the rubble-filled lots and abandoned buildings that scarred the landscape when the artists worked there are now cleared, replaced by open grassy expanses, kids still play trampoline on piles of mattresses discarded in empty lots.

The two artists set up at a large apartment building in a storefront along the sidewalk. It had been the Kelly Block Association. They rolled up the door, left the sign up, and became the "KBA." Next door was a bar, a social club. Most of the models for the figures in the three murals are related in some way to the social club; one of the children is the daughter of a bartender there. Like the methadone clinic across the street from Fashion Moda, the social club was a rich source of models, presenting a microcosm of the neighborhood.

31. First three life casts by Torres, including his portrait of Ahearn as "The Hulk" [center], 1979.

32. Torres holding cast of himself by Ahearn, 1979.

Children drifted in through the storefront door that opened onto the street (fig. 73), and the casting activity attracted people, especially kids. The place eventually became a combination of after-school care, clubhouse, and studio.

We Are Family (fig. 50) is Ahearn and Torres' first mural executed at the KBA. An old woman, Kate, suspicious of other adults but at ease with children, became the resident grandmother. In the mural, *Kate* (fig. 49) is seated at the center while pairs of teenage pals flank her. Two men from the neighborhood block, *Layman* and *Smokey*, who had supported the project from the beginning, are guardians standing at each end. The arrangement of the figures resembles the format of an altarpiece, with *Kate* in the central place of the Madonna.

In *Life on Dawson Street* (fig. 75), the artists' third mural, *Pedro with Tire* (fig. 71) is the anchoring figure at the center. Animated figures emanate from his solidity: *Barbara* (fig. 72) and *Pat and Selena at Play. Thomas* (fig. 76) leaps, turning toward us. The action-shot quality of *Thomas* was fully realized in the previous mural, *"Banana Kelly" Double Dutch* (fig. 47). Ahearn had seen a troupe of African dancers perform and asked the director if he could cast the girls. He posed them executing that quintessential urban *tour de force*: double dutch (fig. 65). The lively figures are placed in a vignette created by the jump ropes.

Like the street castings, the installations of the murals were community events (frontispiece), with Torres on the scaffold supervising the process and Ahearn below doing crowd control and press relations. The murals remain a part of the neighborhood in the way that the smaller casts are part of people's homes (figs. 79–88). Like the heads and busts, one cast of each mural remains in the neighborhood, and one goes into the art world. But in the case of the mural works, the neighborhood is also the art client, and the museum or collection only the relatively more private buyer.

In 1983, the artists returned to work at Walton Avenue. Living there but working elsewhere had distanced them from their neighbors, and they wanted to regain the intensity of their former

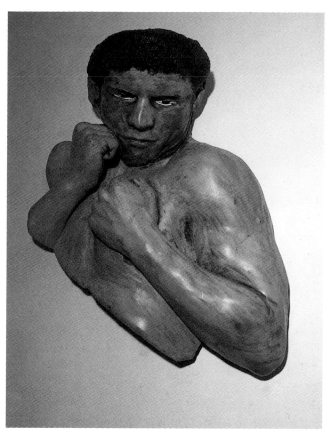

33. Rigoberto Torres with John Ahearn
Boxer 1980
Collection William and Norma Roth

intimacy with the neighborhood. *Back to School* (cover, fig. 92) was made for Ahearn and Torres' own neighborhood when they returned to Walton Avenue. It draws on the experience of the Dawson Street murals, which had been the proving ground for technical challenges presented by making work to be shown outdoors and to be seen at a distance or from a low vantage point.

In *Back to School*, small vignettes convey the neighborhood as a whole with no central image, creating instead the sense of the street and the people who pass along its currents. It is the hypothetical first day of school. *Jay* pushes his bike, *Ralph* reassures *Kido*, and *Maggie and Connie* lean forward as they walk home under the weight of their groceries (fig. 91). *Titi* hovers above them (fig. 89). A huge woman, she lived on the first floor of the Walton Avenue building in

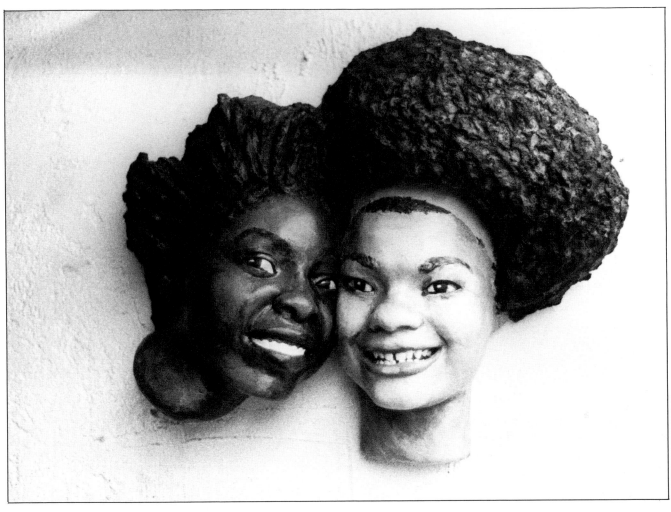

34. John Ahearn, *Yvonne and Maria, Two Girls Laughing* 1979, Collection The Chase Manhattan Bank, N.A.

an apartment with a window that overlooks the courtyard. She saw all. She is shown resting her elbows against the window sill, watching over the scene, a quiet and knowing sibyl of the block.

Counterbalancing the idealized view of childhood in the neighborhood in *Back to School* is *Rat Killers* (fig. 111). During the night, kids stalk the rats attracted to garbage cans behind the building. In the sculpture, two boys stride forward armed with sticks. They are engaged in a lurid task that has the added appeal of risky adventure. The immobile faces of the hunters may hide fear or they may be the rapt masks of celebrants. They resemble Greek *kouroi* and Egyptian sculpture, an urban Huck Finn on the edge of homelessness.

Ahearn's attraction to a collaborative working process—both with Torres and with his models—

may be natural to him because he is a twin. Charlie Ahearn, a filmmaker, is his brother. Ahearn has described his interdependence with Torres as similar to his relationship with Charlie. When Torres left the South Bronx to return to Puerto Rico for a period, Ahearn says that he felt incomplete.

In spite of using the same methods and sharing studio space and working closely for years, Ahearn and Torres have distinct aesthetic approaches. Torres portrays people doing things—circus performers or workers at a task. The "carnival style" is occasionally apparent in Ahearn's work—*El Pirata* (fig. 52) and *David Ortiz (laughing)* (fig. 21) are examples—but this approach, in which inspiration from boardwalk iconography is more explicit, is more Torres' style: *Manny the Magician* (fig. 68), *Mabrick* (fig. 69), *Uncle Tito at the*

Liquor Store (fig. 70).

Ahearn's relationship with his models reflects both the tradition of the commissioned portrait painter to please the sitter and his own sense of obligation to "give 'em their best shot." He steps back to allow the sitter a large degree of control.

Ahearn and Torres' work hovers between realism and expressionism. George Segal, a sculptor of the preceding generation, uses plaster casts of figures to create tableaux, frozen moments that bespeak the undercurrents of human relationships. The surfaces are left rough and are generally white. Despite his use of the life-cast process, Segal is not a portraitist. He is more concerned with conveying emotional situations than he is in creating a likeness. In Ahearn and Torres' work, the force of the person who was the model is palpable. The pathos that could overtake the image is downplayed. Dignity is conveyed through understatement.

Ahearn and Torres' work has little in common with that of the superrealists Duane Hanson or John DeAndrea. Hanson and DeAndrea rely on the viewer's shock in misperceiving that the figure is a real person; it is work keyed to sensation. In spite of the life-cast process, at no time would a viewer mistake an Ahearn or Torres work for an actual person. Details in the sculptural form, and especially in the painting in the case of Ahearn's work, are neither illusionistic nor documentary.[8] They have an artifact quality, evoking something well preserved from an earlier time. The expressionistic way that Ahearn paints the casts adds force to the work. The heightened emotionality of the painting makes them say, "Pay attention, this is a viable life to be considered."

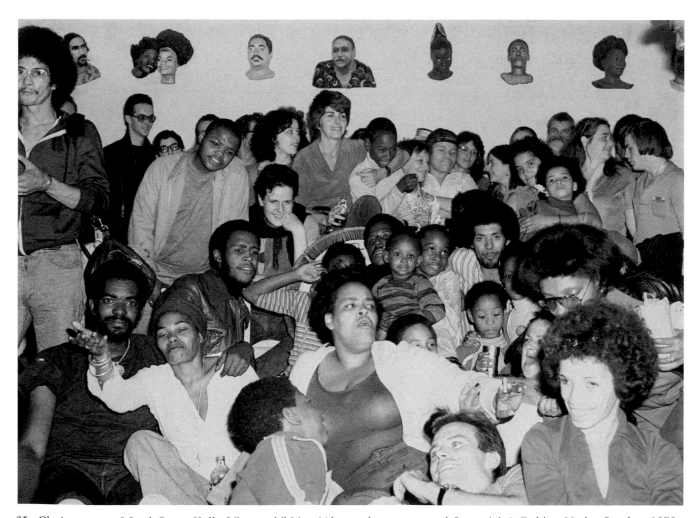

35. Closing party of *South Bronx Hall of Fame* exhibition [Ahearn, bottom, second from right], Fashion Moda, October 1979.

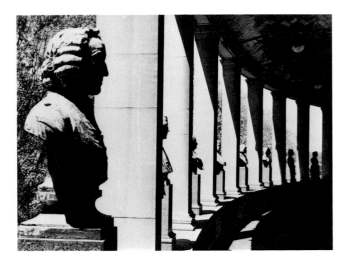

36. The Hall of Fame of Great Americans, on the campus of Bronx Community College of the City University of New York, April 1991.

While it is now virtually unarguable that greater inclusiveness in cultural institutions is right and inevitable, the debate in defining the process by which multiculturalism can best serve to support the greatest inclusiveness while still retaining the vitality of each culture's distinct contributions is gathering force. One side attacks assimilation—participation in mainstream, still white-dominated institutions—as a crypto-racist force; the other deplores the isolation of cultural identities—recoiling from separate and rarely equal contexts—as balkanization. The first view supports a belief that only those of like cultural background can possibly interpret the work of a particular group; the second prefers infusion of multicultural energies into the mainstream by artists from diverse communities based on the belief that art can be understood at a variety of levels.

The danger of sectarianism is that it would continue to allow the work of artists of color to be viewed as special cases. The goal should be to cut across cultural boundaries and redefine aesthetics to embrace a comprehensive range of sources. The notion of "quality," that modernist byword, is entirely subjective. The question is whose subjectivity?

Multiculturalism, like any idea with currency, runs the risk of being the intellectual fashion.

Terminology becomes charged with political weight. The enforcement of an ideology, gradually deleting options, would muffle discussion and allow the issue to devolve into a formula. The problem with fashion is that it changes and that it finally undermines the motives for crucial change.

Not far from the neighborhood where Ahearn and Torres work, just north of the Cross Bronx Expressway, is the Hall of Fame of Great Americans (fig. 36). It was designed by the great nineteenth-century American architect Stanford White, with a dome, balconies, Tiffany glass windows, and a vast marble colonnade. It houses ninety-seven portrait busts of great Americans by such renowned sculptors as Daniel Chester French, who designed the Lincoln Memorial in Washington, D.C.; James Earle Fraser, who executed the figures of Justice and Law for the United States Supreme Court; and Frederick MacMonnies, who created the reliefs on the monumental arch at the entrance to Washington Square Park at the base of Fifth Avenue in New York. The inscription over the gate at the Hall of Fame advises: "Take counsel here of wisdom, beauty, power" If the mission of multiculturalism is fulfilled, we can expect some homegrown candidates for this monument.

Notes

1. Joe Lewis in an interview April 15, 1991.
2. Brooke Alexander in an interview March 9, 1991.
3. John Ahearn in an interview March 7, 1991.
4. Joe Lewis in an interview April 15, 1991.
5. Raymond Garcia in an interview March 7, 1991.
6. Raymond Garcia in an interview March 7, 1991.
7. John Ahearn in an interview March 8, 1991.
8. Steve Poleskie, one of Ahearn's professors at Cornell University, recalls that Ahearn emulated the painting style of Vincent van Gogh, even going so far as to paint *en plein air* in the fields. Steve Poleskie in a telephone interview March 19, 1991.

opposite:
37. Ahearn's apartment/studio on Walton Avenue. Ahearn [foreground] working on cast of *Boobie (Sneakertown U.S.A.)*; Torres [seated on couch, left] and David Ortiz, spring 1981. Casts in room: Ahearn's *Mario and Norma* [on chair] and *Migna* [on wall, center]; and Torres' *Myra* [on wall, left] and *Esther* [on wall, right]. Panoramic photo [fig. 51] is on wall.

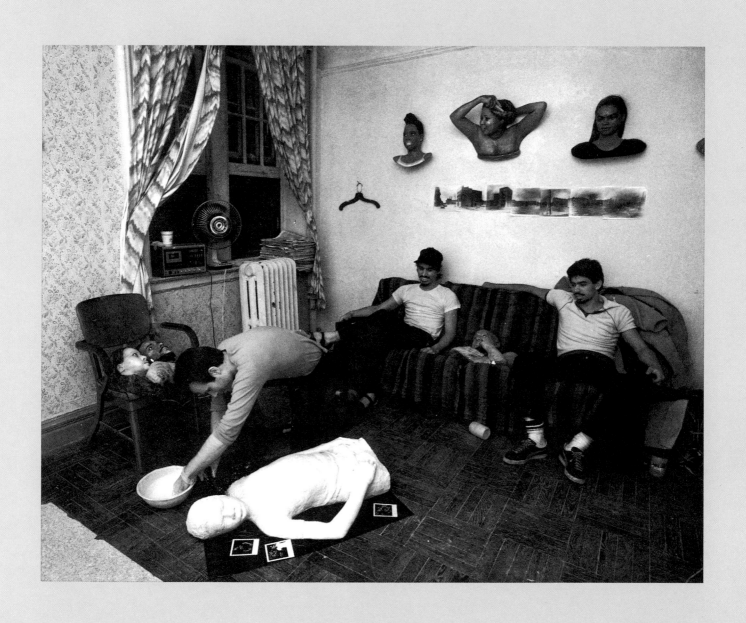

1980-81

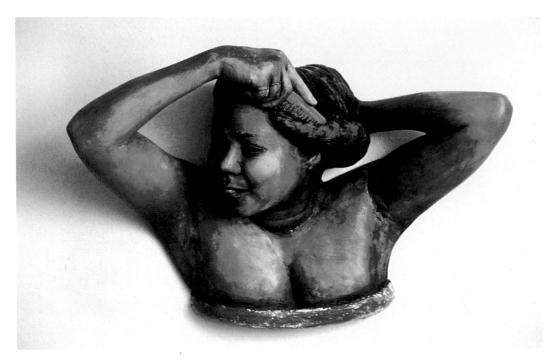

38. John Ahearn
Migna 1981
Rubell Family Collection

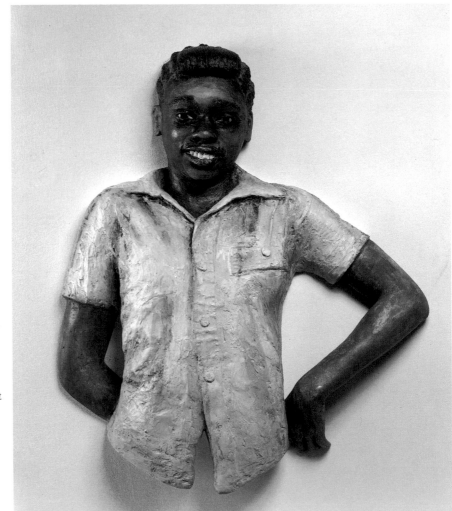

39. John Ahearn
Bernice 1981
Collection The Metropolitan Museum of Art
Gift of Barbara and Eugene Schwartz, 1988
(1988.417.4 III)

opposite:

40. John Ahearn
Maria (laughing) 1981
Collection Lannan Foundation, Los Angeles

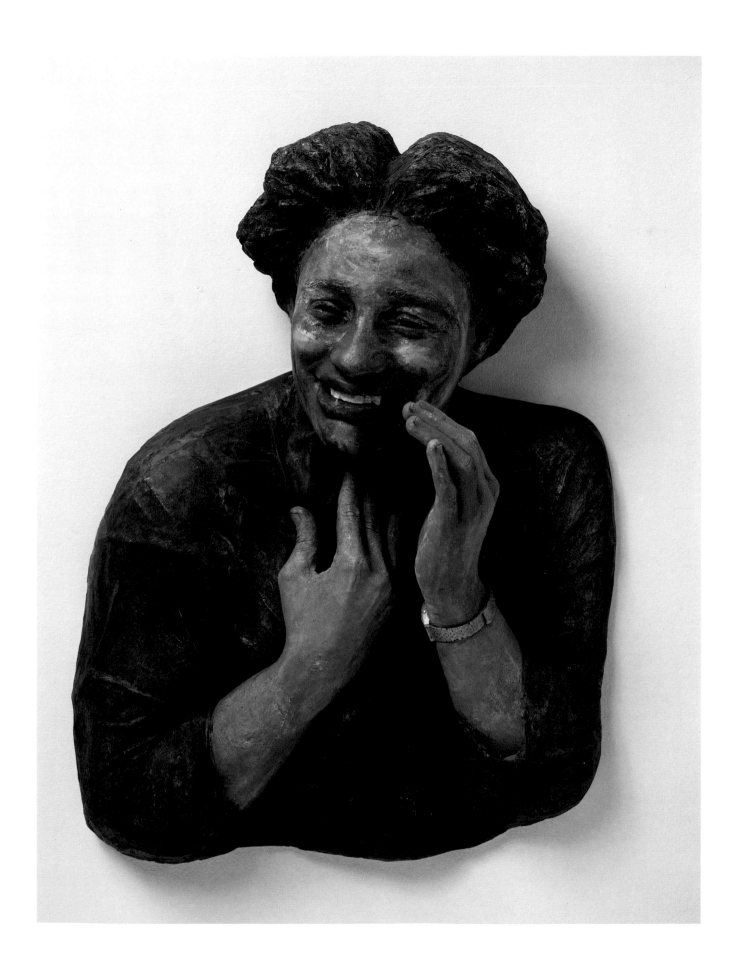

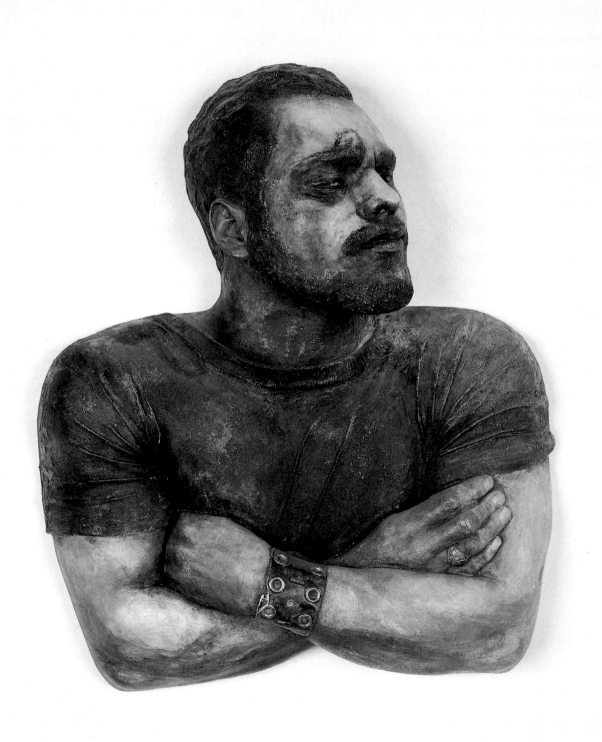

41. John Ahearn
Luis with Bite in Forehead 1980
Collection The Museum of Contemporary Art, Los Angeles
The Barry Lowen Collection

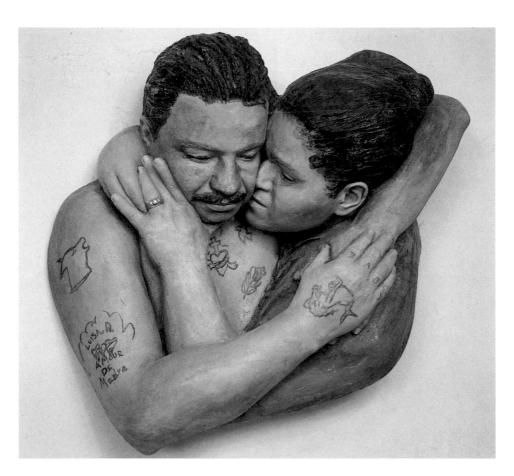

42. John Ahearn
Luis and Virginia Arroyo 1980
Collection the artist

A different cast of Luis and
Virginia is shown in fig. 83.

43. John Ahearn
David and B.B. 1980
[not in exhibition]
Collection Neue Galerie–
Sammlung Ludwig, Aachen,
Germany

Brothers David and B.B. Ortiz,
Torres' cousins, were originally
cast for the *South Bronx Hall
of Fame* exhibition, 1979. This
later cast commemorates David's
return from the army.

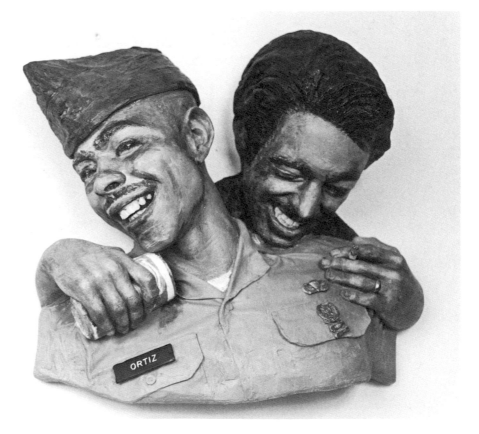

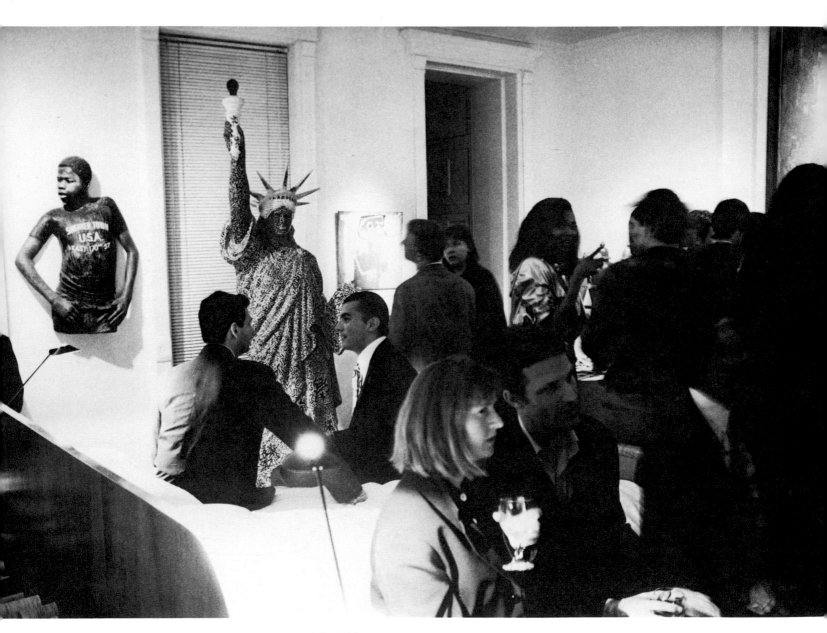

44. Party after opening of Whitney Biennial, 1991, at
the home of Don and Mera Rubell: John Ahearn, *Boobie
(Sneakertown U.S.A.)* 1981 [on wall] and a Statue of Liberty
by Keith Haring.

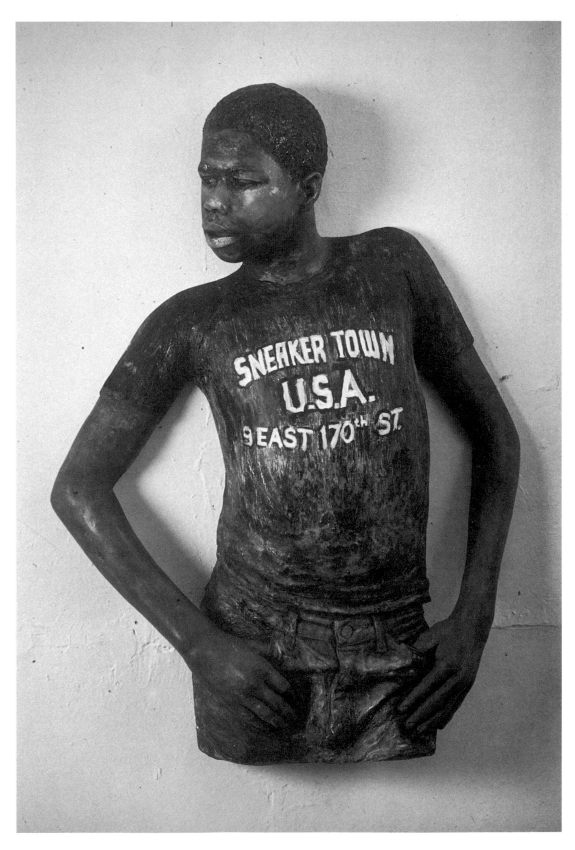

45. John Ahearn
Boobie (Sneakertown U.S.A.) 1981
Rubell Family Collection

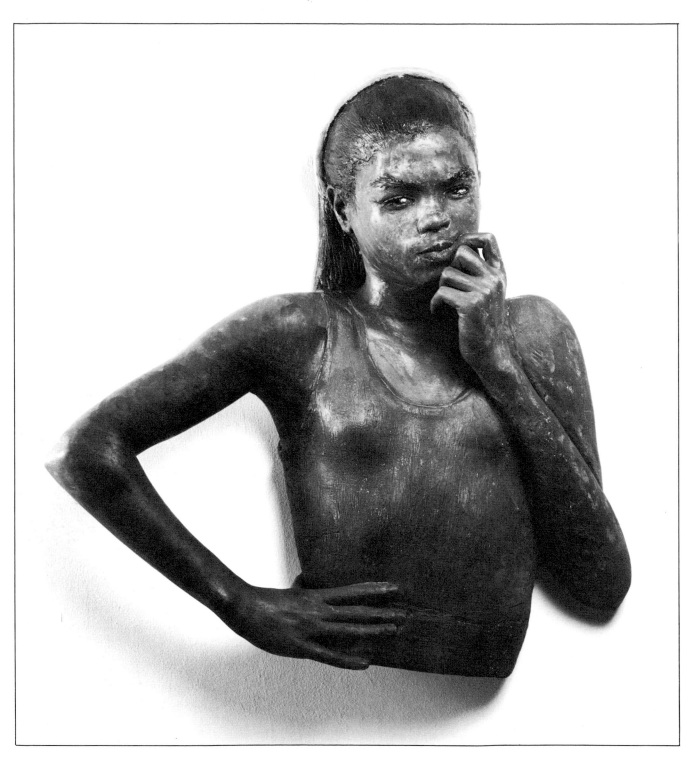

46. John Ahearn
Esther (in the sixth grade) 1981
Collection the artist

opposite:
47. John Ahearn and Rigoberto Torres
"Banana Kelly" Double Dutch 1981–82
Kelly Street at Intervale Avenue, Bronx

The nickname "Banana Kelly" is derived from the shape of the block of buildings. *Homage to the People of the Bronx: Double Dutch on Kelly Street I*, from The Eli Broad Family Foundation, Santa Monica, California, is included in the exhibition.

Dawson Street

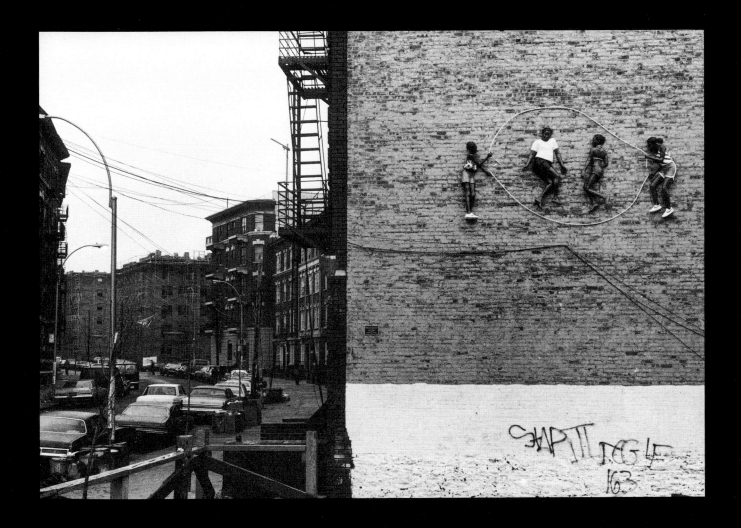

1981-83

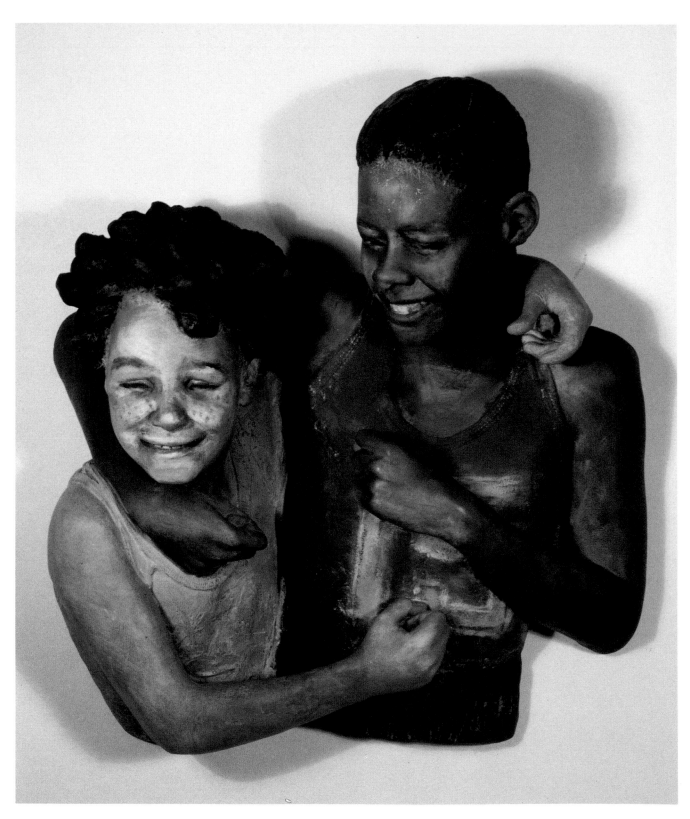

48. John Ahearn
Victor and Ernest 1982
Collection The Foundation to Life, Inc.

A different version of this cast is part of
the *We Are Family* mural [fig. 50].

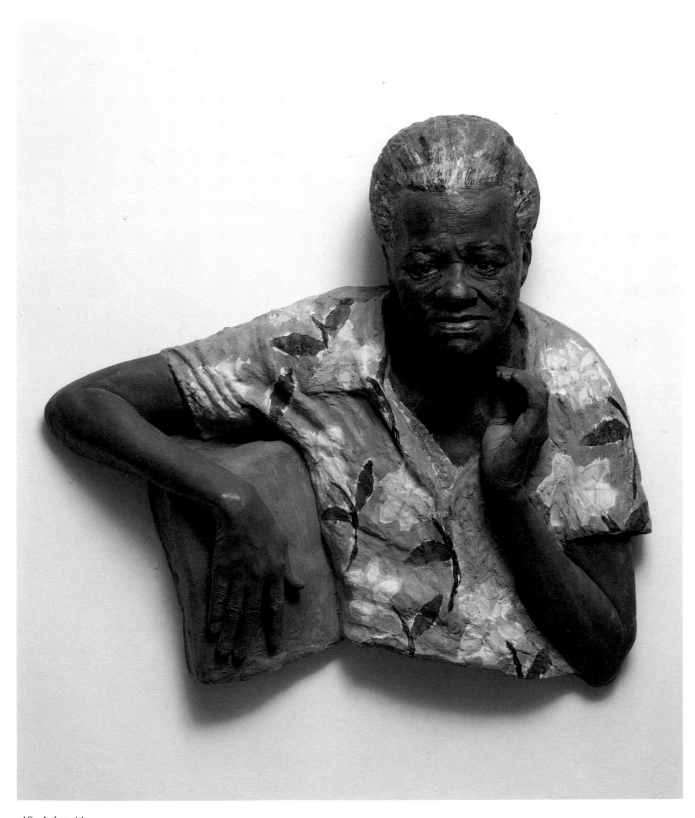

49. John Ahearn
Kate 1982
Collection the artist

A different version of this cast is part of
the *We Are Family* mural [fig. 50].

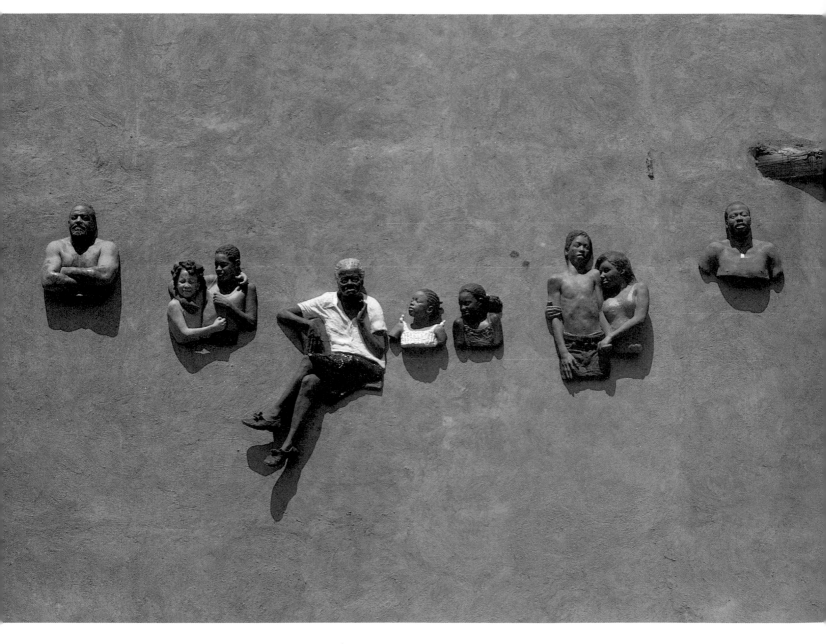

50. John Ahearn and Rigoberto Torres
We Are Family 1981–82
[left to right] *Layman, Victor and Ernest, Kate,*
Tawana and Staice, Felix and Iris, and *Smokey.*
Fox Street at Intervale Avenue, Bronx

Different versions of the mural casts are included in the
exhibition:
Victor and Ernest [fig. 48], Collection The Foundation to
Life, Inc.
Kate [fig. 49], Collection John Ahearn
Tawana and Staice, Collection Cheryl and Henry Welt

pages 42–43:
51. Panoramic view of Dawson Street neighborhood
looking west on Intervale Avenue, Bronx, including future
site of *"Banana Kelly" Double Dutch* mural [page 43, center],
March 1981. This photograph was taken by Ahearn and
Torres on their first visit to the area together, prior to
opening the studio there. Most of the area in the left half
of this photo is now a public park.

Love Among the Ruins –
An Appreciation in Three Parts

MICHAEL VENTURA

Part I. Relief at the Death of the Museums

The sculpture of John Ahearn and Rigoberto Torres takes me back, and I will have to take you back with me, for my response to their art is both more and less than a critique. It is a memory and a hope. So, first, the memory.

It has been many, many years since I went back to Beekman Avenue in the South Bronx or Decatur Street in Brooklyn, and I have put myself many miles from them, but they follow me in my dreams. Even before crack, arson, and kids armed with automatic weapons, they were places of hunger, fear, and the look that parents get when they have lived too long with the knowledge that they cannot protect their children. But it was in those places that my mother taught me to read. She let me know, not through lectures but through her presence, that to read and to survive were (for me) absolutely linked. On the fire escapes and rooftops, I read to survive.

It must have been 1956 or so when I read my first novel, a book I happened on in the library, *Star Man's Son* by André Norton, a science-fiction tale about the descendants of nuclear war survivors. A young man from a tribe deep in the wilderness sets out to find and explore the legendary ruined cities of the Old Ones. On my fire escape, I knew he was coming toward me, that I was one of the Old Ones who populated the place for which he had such awe. In the novel, the city has been spared a direct nuclear hit, but radiation has killed us, our bones lie everywhere, and three

hundred years have left the streets ruptured, the buildings slowly crumbling. But the passage that struck me most deeply, and which I have searched out after all this time to read to you, comes after the hero has walked up a great wide staircase into a building that is not like the rest, a place I took to be The Metropolitan Museum of Art.

He wandered through the high-ceilinged rooms, his boots making splotchy tracks in the fine dust crisscrossed with the spoor of small animals. He brushed the dust from the tops of cases and tried to spell out the blotched and faded signs. Grotesque stone heads leered or stared blindly through the murk, and tatters of powdery canvas hung dismally from worm-eaten frames in what had once been picture galleries. [1]

What I am about to say may seem perverse, but so be it: These words are among the most liberating I have ever read. Of course, I couldn't articulate it at the time, even to myself, but I felt a double flash of revelation. The first was that the city was vulnerable. Was as vulnerable, in its own way, as I. This city, this enormous entity, existing all around me yet entirely beyond me, beyond my ability to influence or perhaps even survive it— this city could, would, someday, fall. It, too, was weak. It, too, had something to be afraid of. For I knew in my bones, beyond question, that the city was not on my side. So, if the city, too, could be afraid, that gave me a feeling of power.

The second revelation, the second relief, was that the museums would not last. My mother took me to them often (the city museums were free

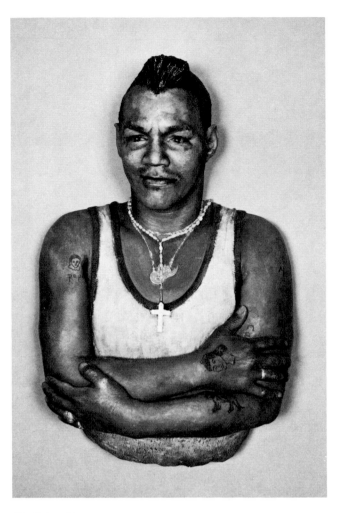

52. John Ahearn
El Pirata 1982
Collection Susan and Lewis Manilow

spoke to us, it was with that slight thickening of the voice that people have when they visit the sick in hospitals. But, really, it was the art that made me most afraid. What was it about? *Who* was it about? Here and there, I would recognize something as almost human, almost natural ("natural," for me, meant the street), but "almost" wasn't near enough. Every hall, every wall, had one message for me, and it was the same message I saw on television: "You don't exist."

Yes, the TV and the museum had a lot in common. There was nothing of my life in either one. Being a child, I didn't, could not allow myself to, feel my growing rage at being told in so many ways that I did not exist. But the rage was building within me, and it was this rage that was appeased and gratified at "tatters of powdery canvas hung dismally from worm-eaten frames."[2]

You can see why I have such affection and respect for the art of John Ahearn and Rigoberto Torres. It is an art that says, "You exist." To me, and to anyone of whatever color who has lived the lives etched in the faces of these sculptures, this art says, "You are alive, you have lived, you are beautiful, you are worthy of beauty."

in those days). I loved the American Museum of Natural History, the dinosaurs especially. I thought of them as enormous rats; they played into my fantasies. But The Metropolitan Museum of Art—however much my mother loved it, it made me afraid. For one thing, the people there weren't like us. Our best clothes weren't as nice as their casual dress. They spoke differently. And if they

Part II. The Politics of Beauty

I t is the task of the critic to be suspicious, and many critics are suspicious of the quality of beauty, sometimes rightly so. Sometimes it's because we are, shall we say, intellectually shy and easily embarrassed, but often we don't believe beauty because we believe our fears more. How many critic-types don't feel fear when walking past three young men-of-color on a quiet street at night? How many middle-class folk have no suspicion at the mere sight of people on the street

—frightened even of the very liveliness of the street? In a society that bombards us with negative images of everyone excluded from affluence, how many are free of these taints?

With one graceful stroke, Ahearn and Torres have outflanked critical suspicion of the beauties they present: these sculptures are cast from life. Ahearn and Torres live and work in the South Bronx, and the people of their neighborhood are the subjects, the actual faces, of their art. Nobody can say they're "making up" the beauty here. Instead, they're giving it a form—which is to say, giving it a home.

When they do this, they're not being documentarists (though there is an element of documentation in any art, even the abstract); rather, they are, in the psychological sense, "framing." That is, the fact that these faces are cast from life turns any discussion of the art toward that life and, in so doing, reveals the poverty of criticism. For we can discuss the colors, discuss outdoor vs. indoor, gallery vs. street, abstract vs. whatever, but what is beyond discussion (or rather, where discussion breaks down into pretension and nonsense) are these faces. Fail to discuss the faces, and you're not discussing the art. Discuss the faces—and what?

Discuss *El Pirata* (fig. 52)! Discuss *Andrea* (fig. 53) or *Girl with Red Halter Top* (fig. 57). You can blab about the form a bit, or you can retreat into sociology, but as soon as you start to talk about whether the piece is "heroic" or "sentimental" or "realistic," you sound like an idiot, because you have stepped into the psychological "frame" of these faces. What these faces know and don't know, what they feel and can't feel, what they want and will and won't do, is beyond academia and gallery-speak. Each face makes you sense, not the specifics, but the *realm* of its psyche. You are forced to say to yourself, on a level below words, "These people exist."

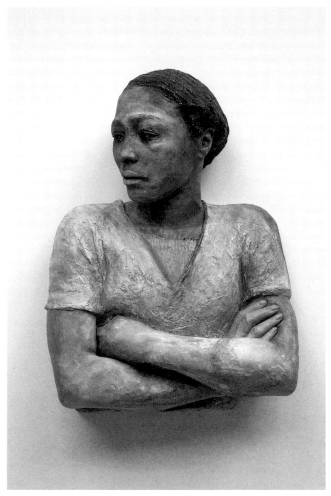

53. John Ahearn
Andrea 1982
Collection Susan and Lewis Manilow

And there is nothing more rare in our society than freely to meet the existence of others without terms.

Whether it is the subjects themselves, and their neighbors, viewing these pieces on their own streets, or whether it is you and I in a museum or gallery—the unavoidable and irreducible *presence* of these pieces, the vivid beauty and existence

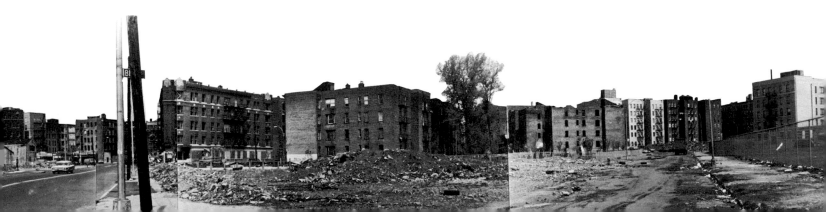

they express, is a moral and aesthetic statement of the highest order. When people of the streets see themselves and their kind framed so vividly, what they take for granted in their own mirrors comes to life and speaks to them: "You are beautiful and you are worthy of beauty." Inevitably, this is a political as well as an aesthetic statement, for it means that things must change. We who look from a greater distance are made to see through and past our preconceptions into the world of shared beauty that is, or was, America's dream.

Benito Juarez said, "Peace is the respect for the rights of others."[3] In their art, John Ahearn and Rigoberto Torres turn his sentence a bit so that it reads, with just as much truth, "Peace is the respect for the beauty of others."

Part III. Who Needs an Acropolis Anyway?

There had to be a day when people stopped going to the Acropolis. Things went on pretty much as usual in Athens. Women swept the dust from their doorways in the morning, people bought and sold at the stalls in the market, and there was the clip-clop of the horses and donkeys, the crunching noise of wagon wheels, the ever-present flies, smells of what was cooking, smells of what was rotting, and the sounds of children running about—but no one went to the Acropolis anymore.

At least, not for any real reason. Maybe to take a stroll, or have a quiet talk, or simply to get away from the heat and dust, but not for any

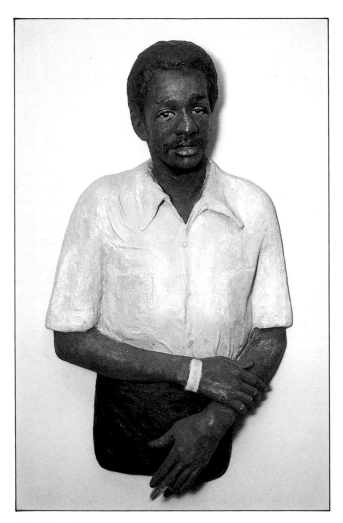

54. John Ahearn
Kassim 1983
Collection William and Norma Roth

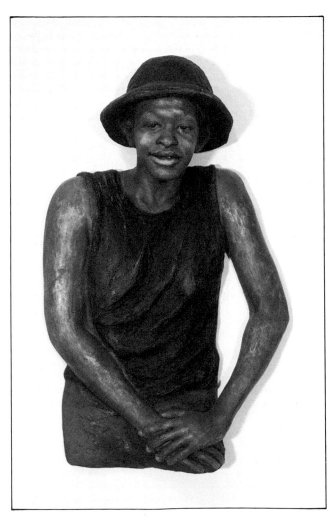

55. John Ahearn
Janice "Peanut" Harvey 1983
Collection Edward R. Downe, Jr.

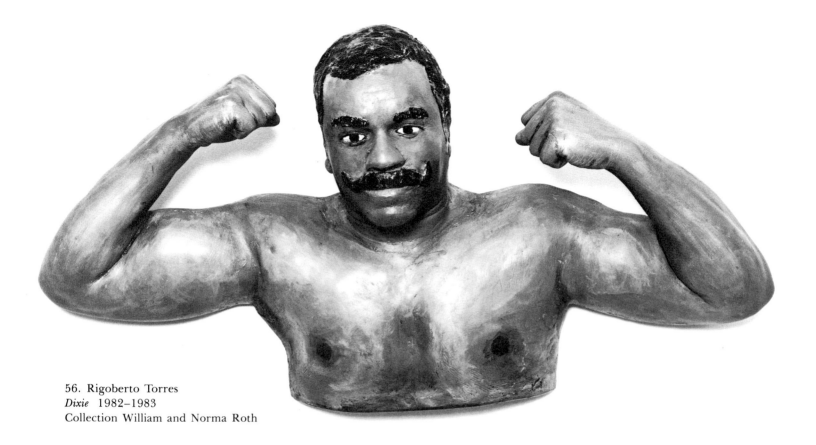

56. Rigoberto Torres
Dixie 1982–1983
Collection William and Norma Roth

reason that had to do with why the Acropolis had been built. The paint peeled off the statues—no one tended them. Pillars fell from an earthquake now and then. The city went on for another two thousand years and more, and it goes on still, but long ago its people forgot whatever was supposed to happen at the Acropolis. On some particular day, the reason for the Acropolis stopped. And on another, unrecorded, but in a way more important day, people stopped missing the reason. On that day, the Acropolis became a ruin.

Which is to say that living among ruins is not new. People have done it for thousands of years, and often whole populations hardly notice when their homeland has become, for all intents and purposes, a ruin. They make their way among streets and structures that were built for other eras, designed for other purposes, and making their way, they more than make do. As has happened in the South Bronx, and in many places in both urban and rural America, they make life as vivid and complex as any, though it goes largely ignored by the official culture, which is always

trying to build a new Acropolis.

"Well, who needs an Acropolis anyway?"

A good New York kind of question, and in a way it is the question that has haunted the arts for most of the century. Ahearn and Torres have answered it by making art of, and in, what most Americans think of as ruins. They choose to place highly sophisticated works in crumbling neighborhoods. They do this not out of some quixotic faith that those neighborhoods will economically revive, or that by showing the beauty of these people our society will finally respond to them with decency. Everyone knows now that this will not happen, and that what the near future holds is, at the very least, more ruins. No, Ahearn and Torres do this because in their work they share the insight of Imamu Amiri Baraka: "All activity is cultural activity A walk is as profound as a system of judging." [4]

Look at the beauty, the passion, and the depth captured in their sculptures, and you see that maybe it's not such a tragedy that our society's Acropolis is crumbling, for the ruins themselves

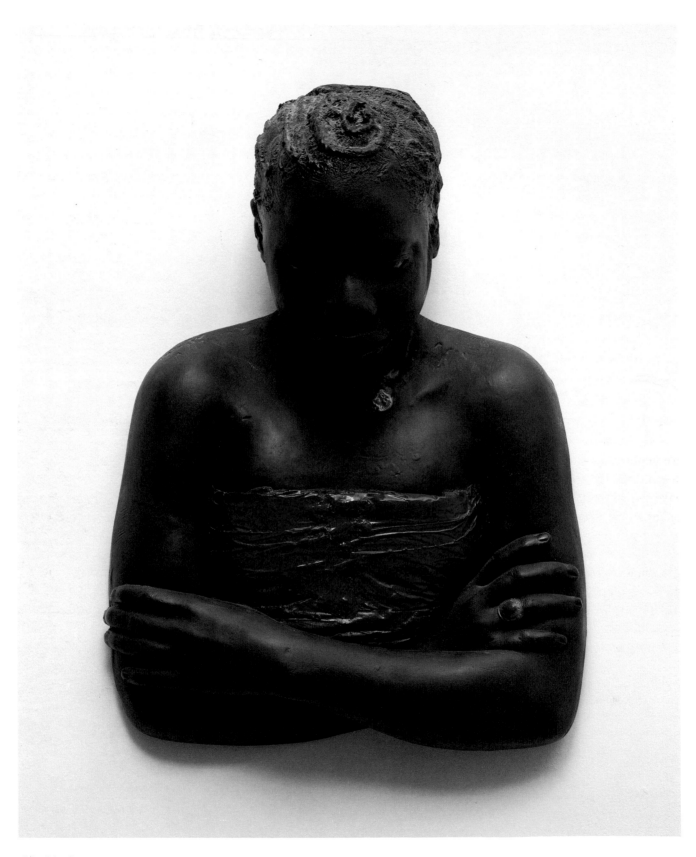

57. Rigoberto Torres
Girl with Red Halter Top 1982–1983
Collection Brooke and Carolyn Alexander

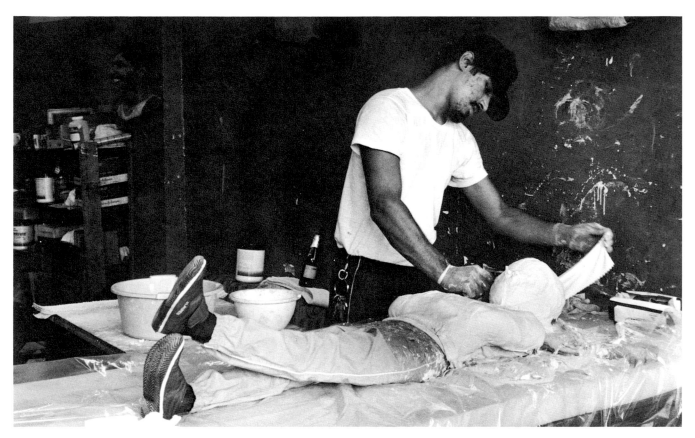

are generating music, art, language, and dance that doesn't need the official art world to be beautiful, have their effect, and help us survive.

For there is a difference between helping the society survive and helping *us* survive. Society is always and merely a form. We are the content. Ahearn and Torres, in making art of, by, and for the ruins, recognize and celebrate that though our society may be dying, *we are living*—and we are struggling to share our lives, which is all, finally, that "culture" means.

Notes

1. André Norton, *Star Man's Son: 2250 A.D.* (New York: Harcourt, Brace & World, Inc., 1952), 64–65.

2. Norton, 64–65.

3. Benito Juarez, in John Reed, *Insurgent Mexico* (New York: International Publishers, 1969), 40.

4. Imamu Amiri Baraka, *In Our Terribleness (Some Elements and Meaning in Black Style)* (Indianapolis: Bobbs-Merrill, 1970), 70.

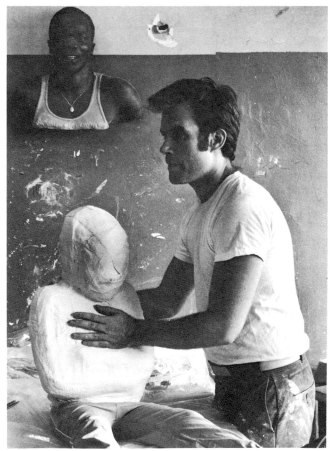

58 & 59. Casting Janel Evans: [top] Torres applying plaster bandages; [bottom] Ahearn preparing to remove cast, Dawson Street studio, 1983.

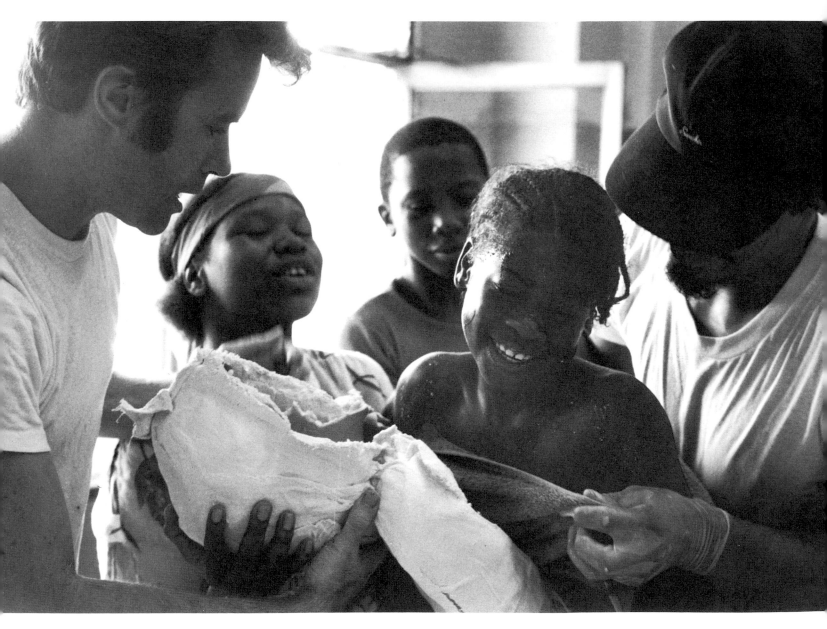

60. [left to right] Ahearn, Liz Murchison, Kiba Hatchet,
Janel Evans emerging from casting mold, and Torres,
Dawson Street studio, 1983.

opposite:

61. John Ahearn
Janel and Audrey 1983
Collection Brooke and Carolyn Alexander

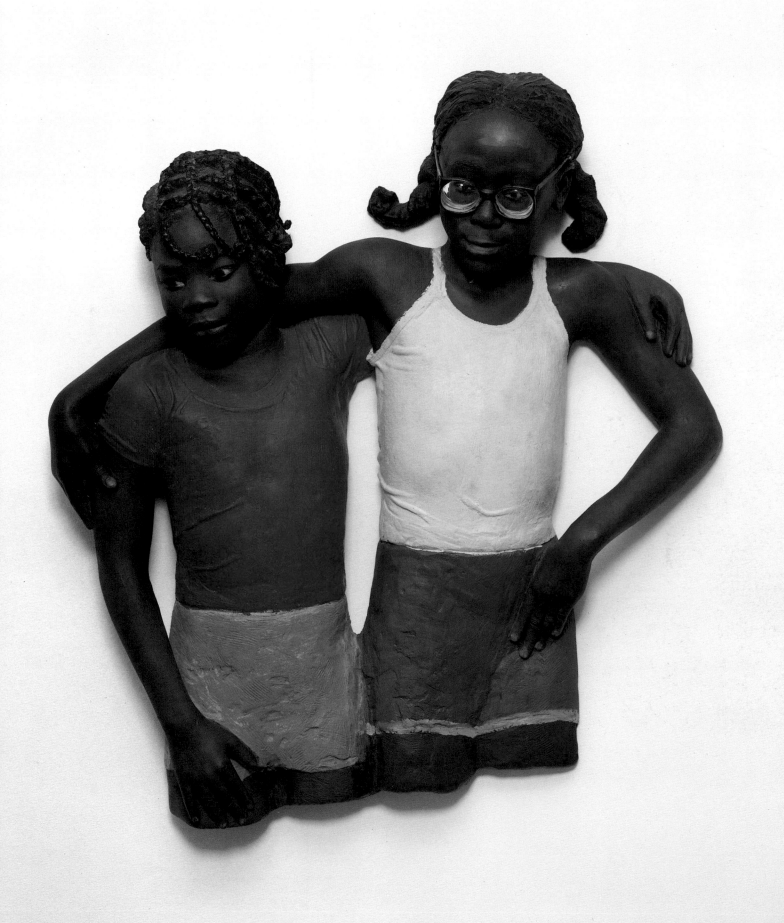

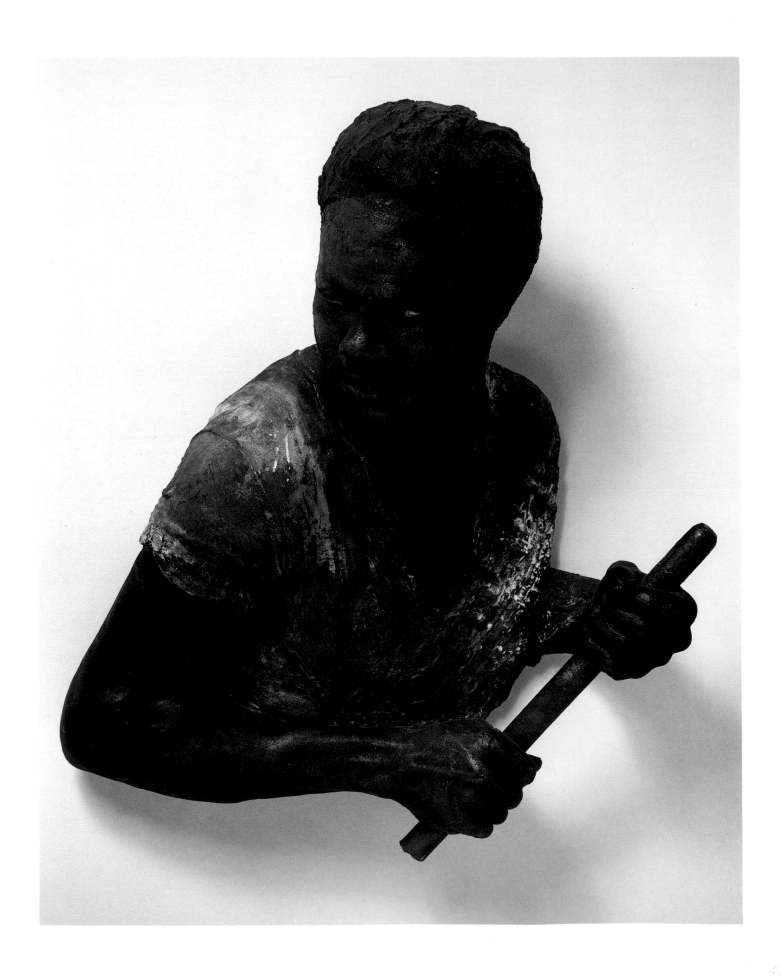

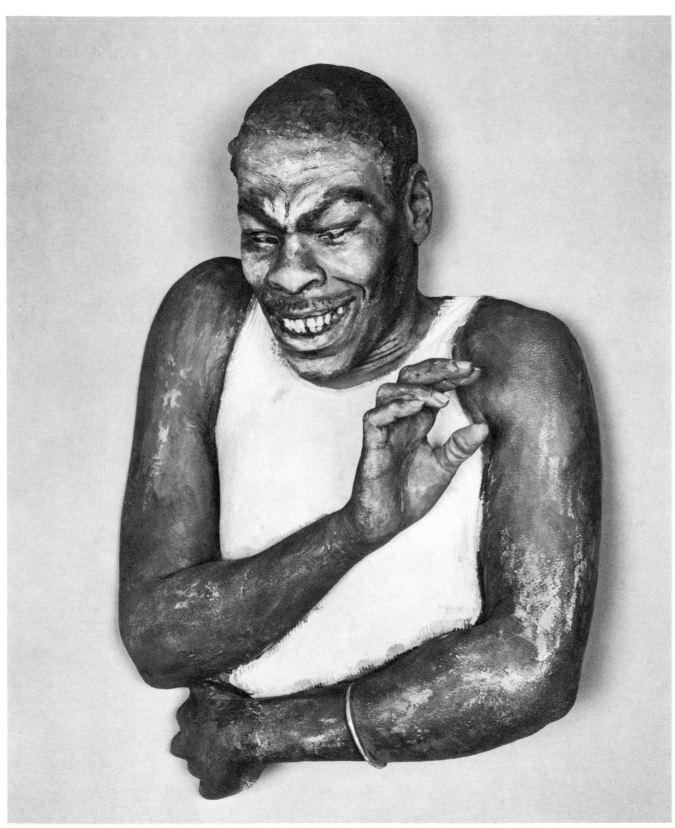

opposite:
62. John Ahearn
Clyde (blue version) 1981
Collection Lannan Foundation, Los Angeles

63. John Ahearn
Charlie I 1982
Collection the artist

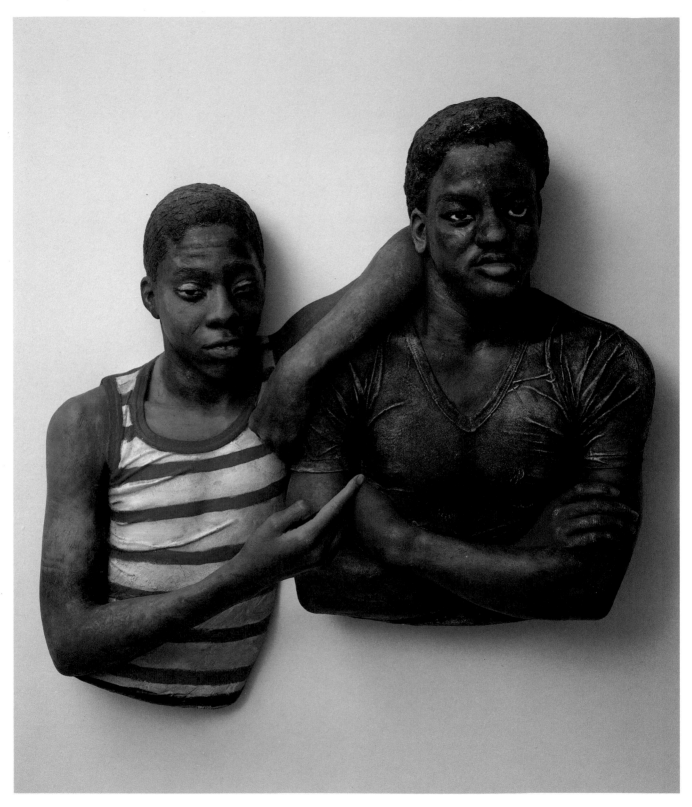

64. John Ahearn
Duane and Al 1982
Collection Munira Nusseibeh and Francisco Hernandez

opposite:
65. [left to right]: LaFreeda Mincey, Javette Potts, Tawana Brown, and Staice Seabrine recreate their roles in the *"Banana Kelly" Double Dutch* mural, which is located on their apartment building, 1982. The mural was vandalized, then reconstructed in 1986.

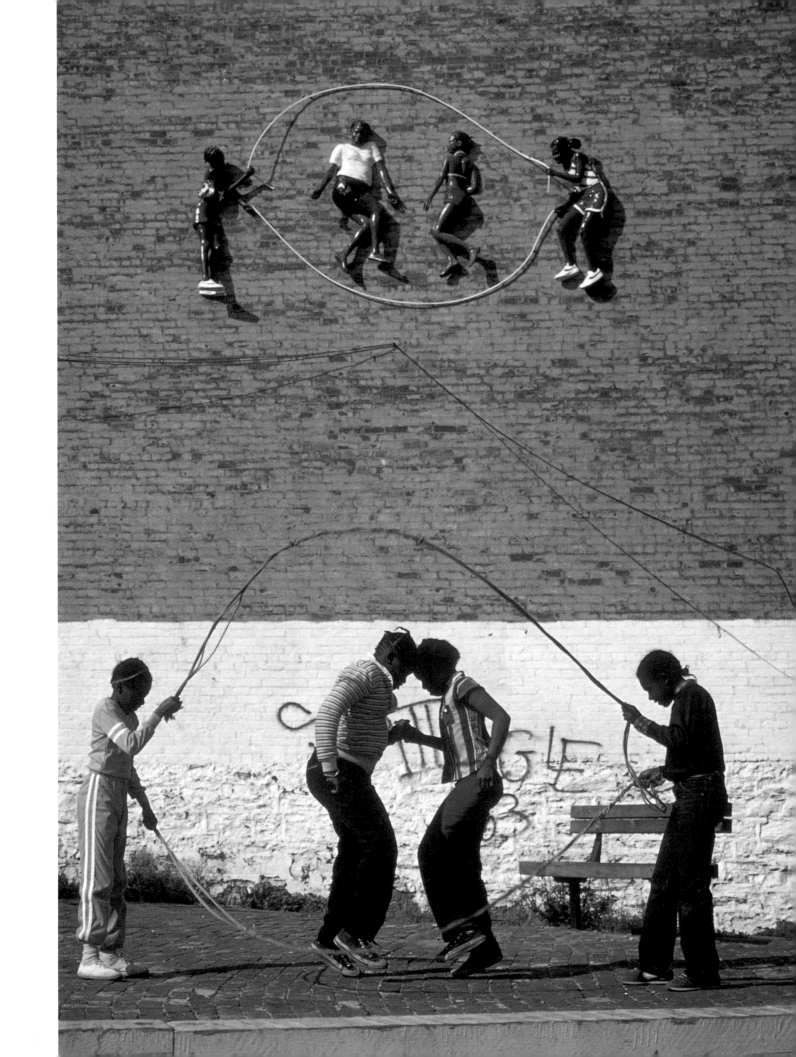

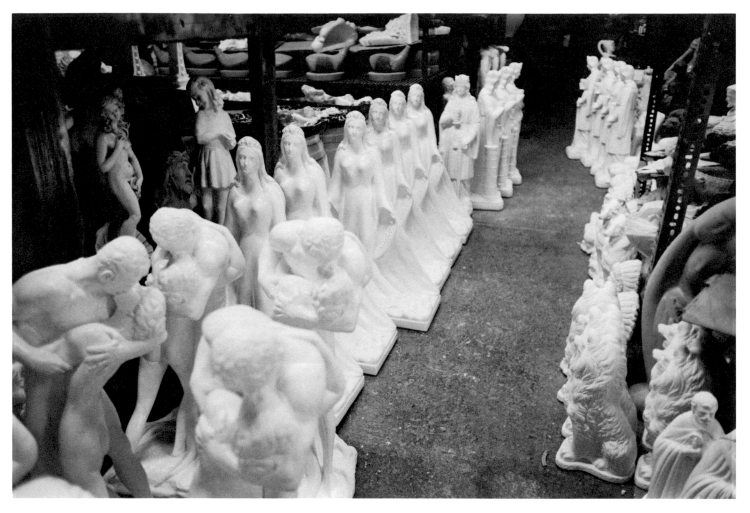

66. Paul's Statuary Co. [formerly C & R Statuary Corporation], 1991.

opposite:
67. Rigoberto Torres
Shorty Working in the C & R Statuary Corporation 1985
Collection John Ahearn

This cast was made at the C & R Statuary factory, four blocks from the Dawson Street "KBA" studio. Torres' uncle Raul Arce, the company's owner, taught the artists fiberglass casting. A major fire destroyed the factory in 1985, one month after *Shorty* was cast. All of Ahearn's and Torres' Dawson Street era molds, which had been stored there, perished. Arce eventually reestablished the business as Paul's Statuary Co.

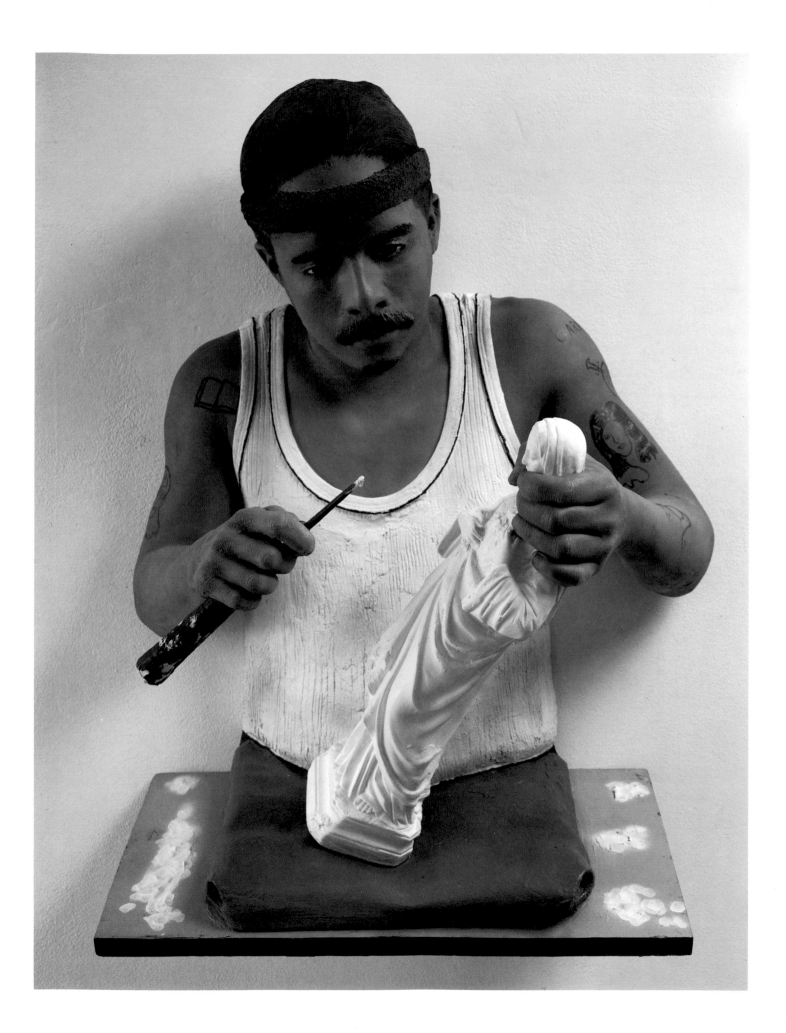

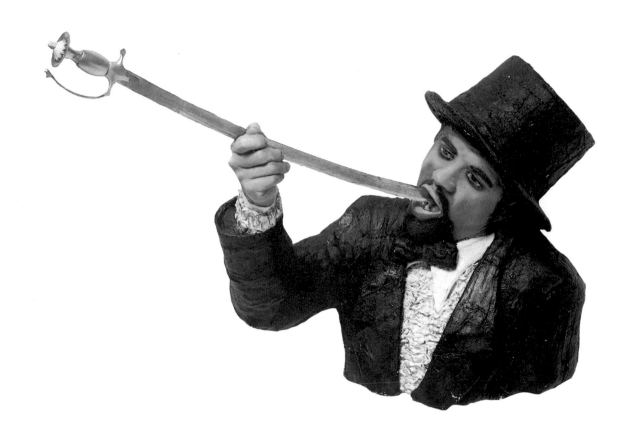

68. Rigoberto Torres
Manny the Magician 1982–1983
Collection Lannan Foundation, Los Angeles

69. Rigoberto Torres
Mabrick 1984
Collection William and Norma Roth

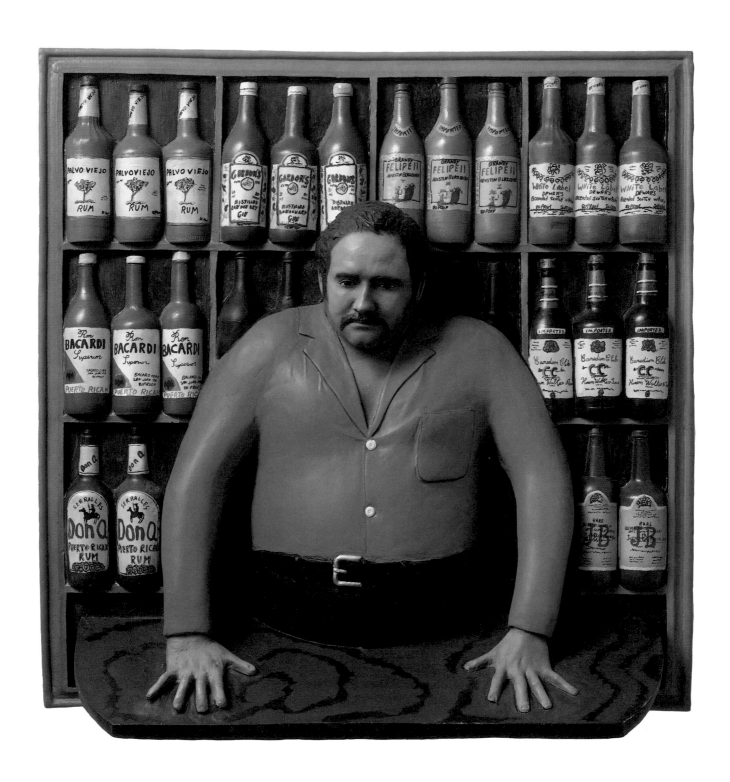

70. Rigoberto Torres
Uncle Tito at the Liquor Store 1983/1985
Collection John Ahearn

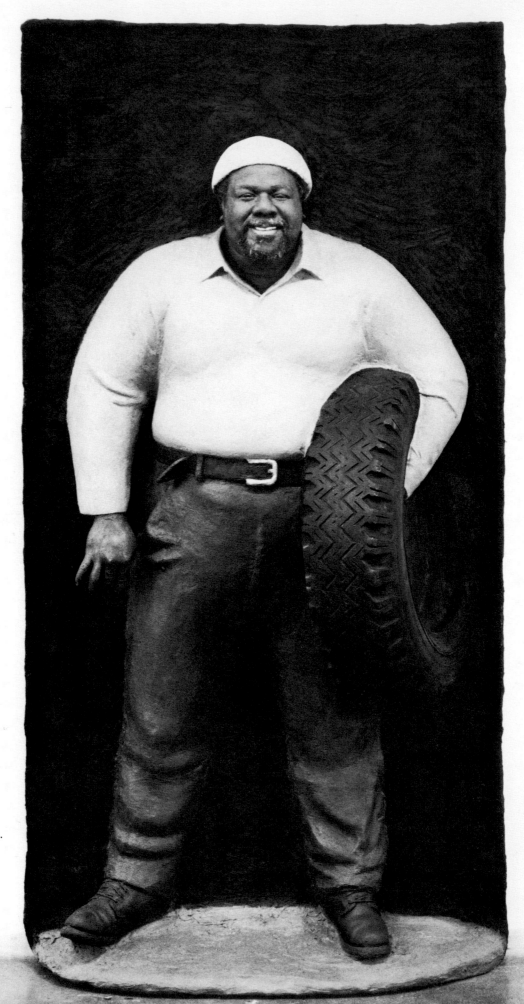

71. John Ahearn
Pedro with Tire
1982/1984
Collection Edward R.
Downe, Jr.

opposite:
72. John Ahearn
Barbara (for Ethiopia)
1982/1985
Collection Edward R.
Downe, Jr.
Installation view in
collector's home, 1991.

Different versions of
these casts are part
of the *Life on Dawson
Street* mural [fig. 75].

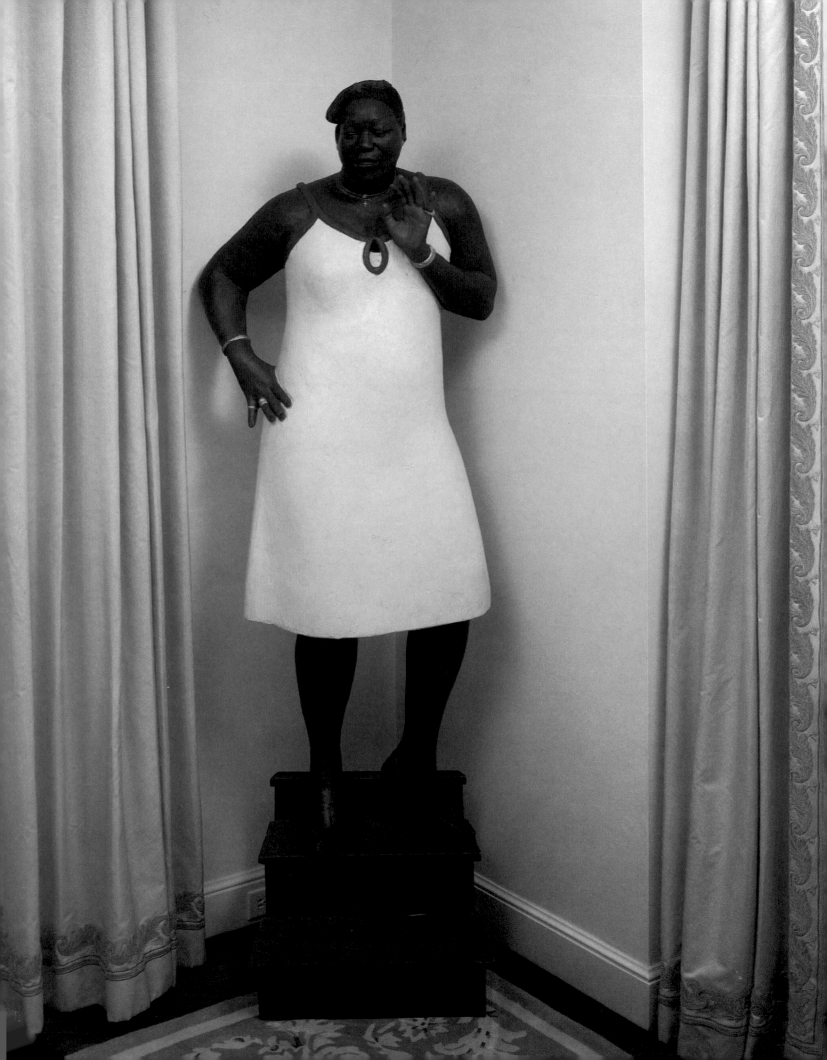

73. Neighborhood kids at the Dawson Street studio; casts in progress for *Life on Dawson Street* mural, 1983.

74. Crowd on Dawson Street watching the casting of Pedro Serrano by Ahearn [left] and Torres [right], 1982.

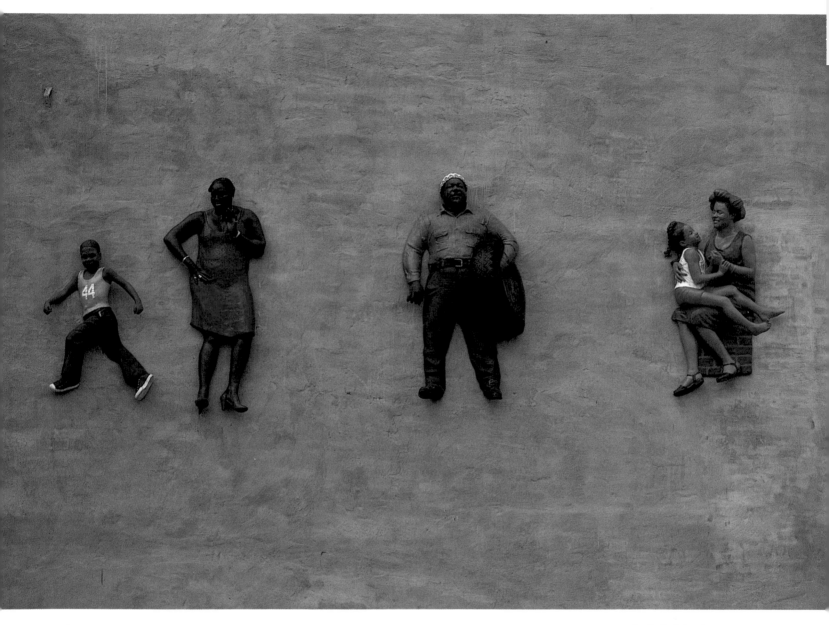

75. John Ahearn and Rigoberto Torres
Life on Dawson Street 1982–83
[left to right] *Thomas, Barbara, Pedro with Tire,* and *Pat and Selena at Play.*
Dawson Street at Longwood Avenue, Bronx

Different versions of the mural casts are included in the exhibition:
Thomas [fig. 76], Collection The Eli Broad Family Foundation, Santa Monica, California
Barbara (for Ethiopia) [fig. 72], Collection Edward R. Downe, Jr.
Pedro with Tire [fig. 71], Collection Edward R. Downe, Jr.
Pat and Selena at Play, Collection John Ahearn

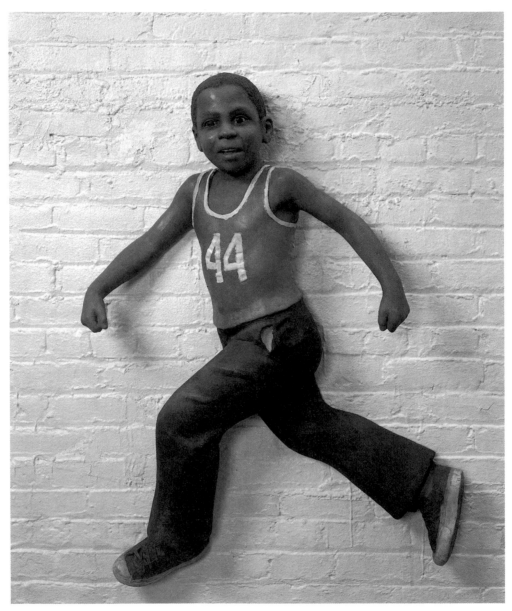

76. John Ahearn
Thomas 1983
Collection The Eli Broad Family Foundation, Santa Monica, California

A different version of this cast is part of the *Life on Dawson Street* mural [fig. 75].

opposite:
77. Walton Avenue during casting of Zuhey Perallon [background, right]. An earlier cast of Zuhey is on wall center [fig. 119], summer 1990. Casts on wall include [left to right] *Kevin, Willie Moore* [fig. 116], *Cynthia,* and *Tico in Wedding Suit* [fig. 120].

Walton Avenue

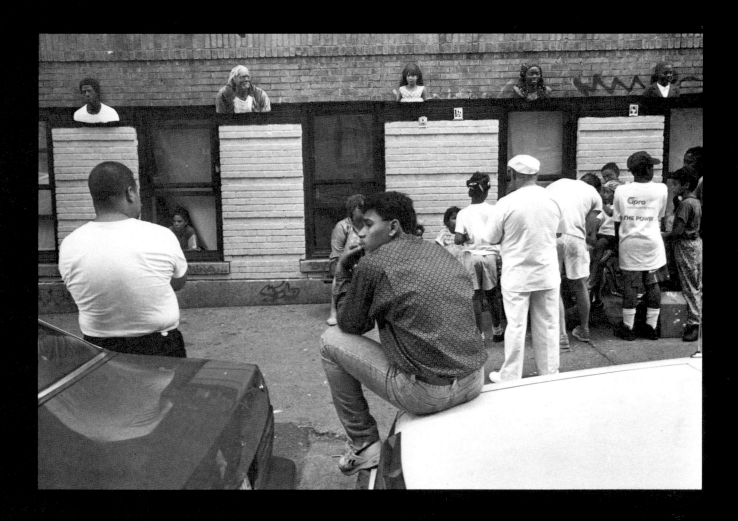

78. John Ahearn
Trudy 1984
Collection Milwaukee Art Museum; given in memory of
Josephine Segel by Jill and William Feldstein, Sidney and
Dorothy Kohl, Kenneth and Audrey Ross and Carole and
Bernard J. Sampson

A different version of this cast is shown in fig. 79.

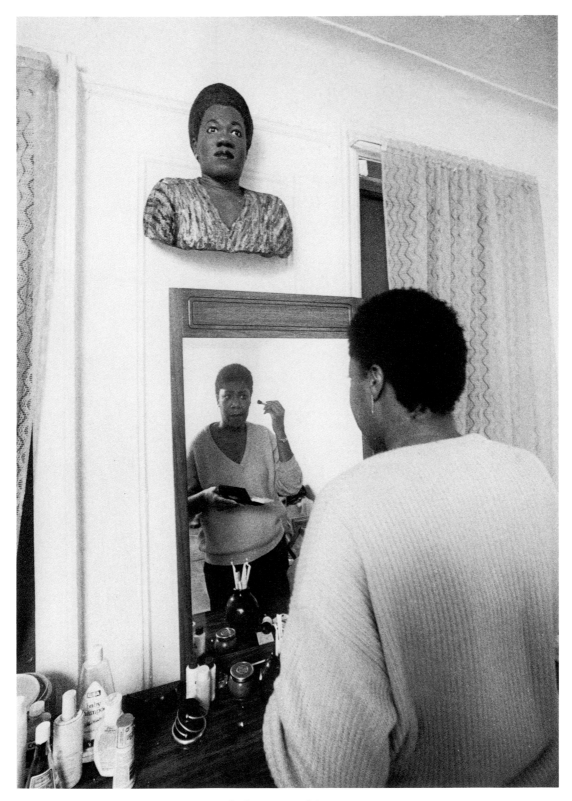

79. In exchange for being cast, many of Ahearn's models, such as Trudy Eames [above], have been given a finished sculpture. During Christmas week, 1986, Ivan Dalla Tana and John Ahearn together photographed some of John's neighbors in their homes. The following selection is from that series of portraits [figs. 80–88].

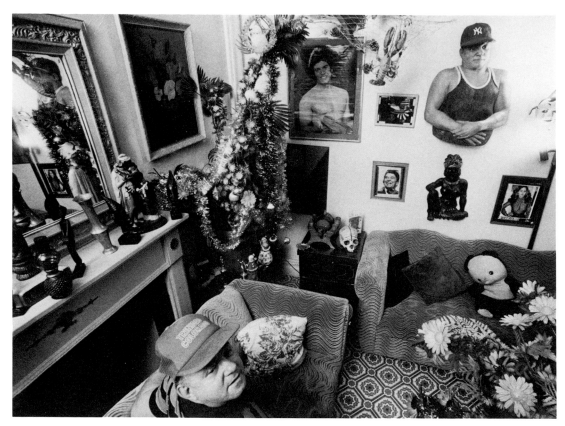

80. Tony Zayas

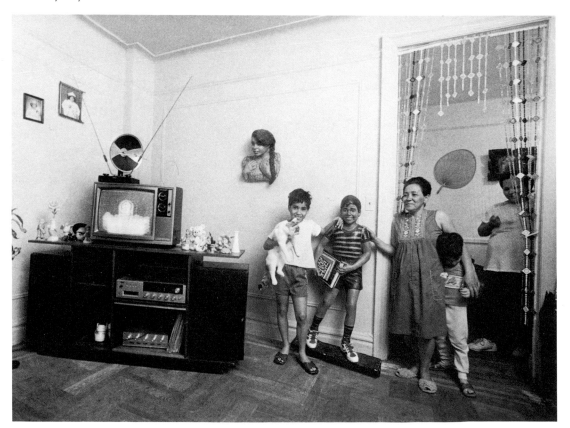

81. Gibbie Gonzalez, with mother and brother, standing beside his sculpture (an additional cast is included in the *Back to School* mural [fig. 92]); a cast of Gibbie's sister, Mari, is on the wall above him.

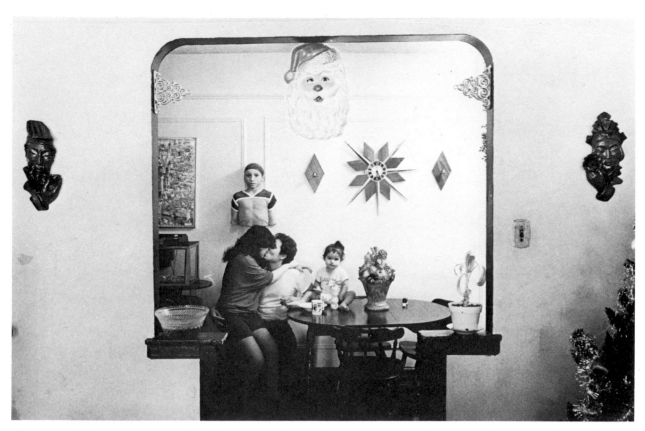

82. Cast of Kido Rosado [on wall], Kido's sister Elizabeth Burgos, her husband, Ariel, and daughter, Stephanie.

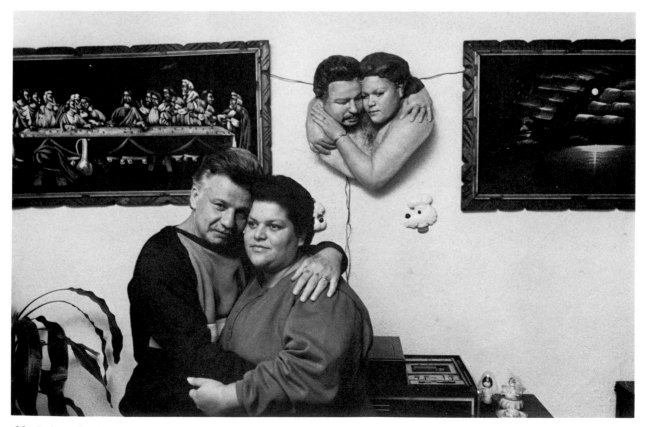

83. Luis and Virginia Arroyo

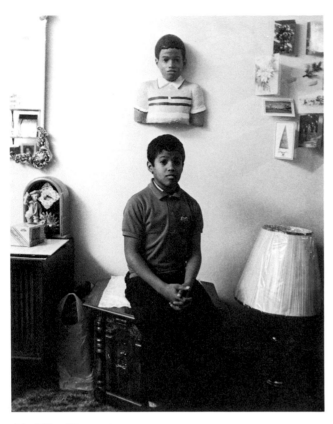

84. Elliot Hernandez

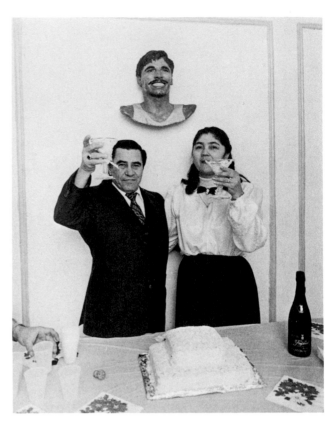

85. Cast of Torres above his parents Benigno and Irmina.

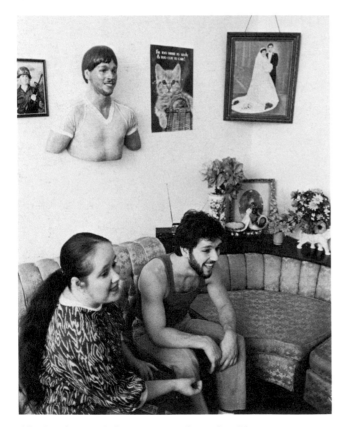

86. Brother and sister Jesus and Emelyn Pitre.

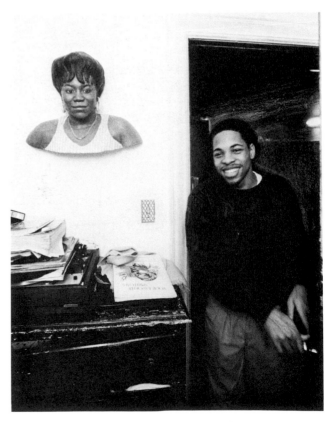

87. Studio assistant Kevin Crocker's brother Gary, with cast of sister Kim.

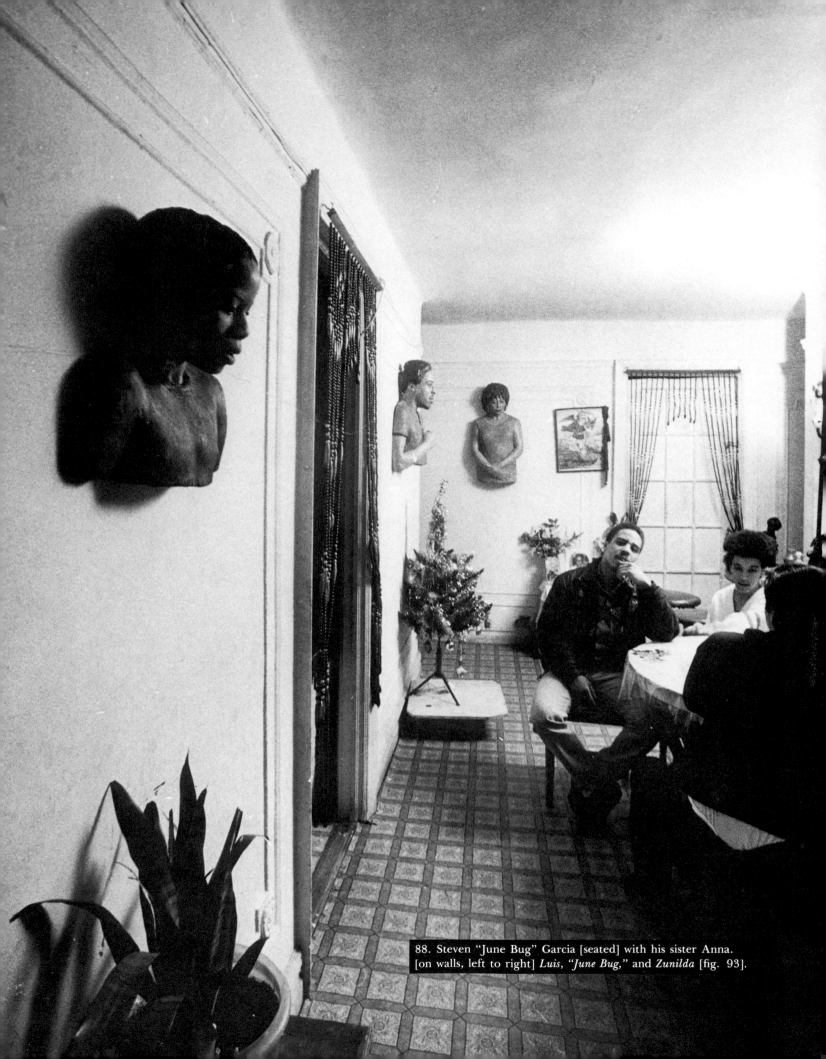

88. Steven "June Bug" Garcia [seated] with his sister Anna.
[on walls, left to right] *Luis,* "*June Bug,*" and *Zunilda* [fig. 93].

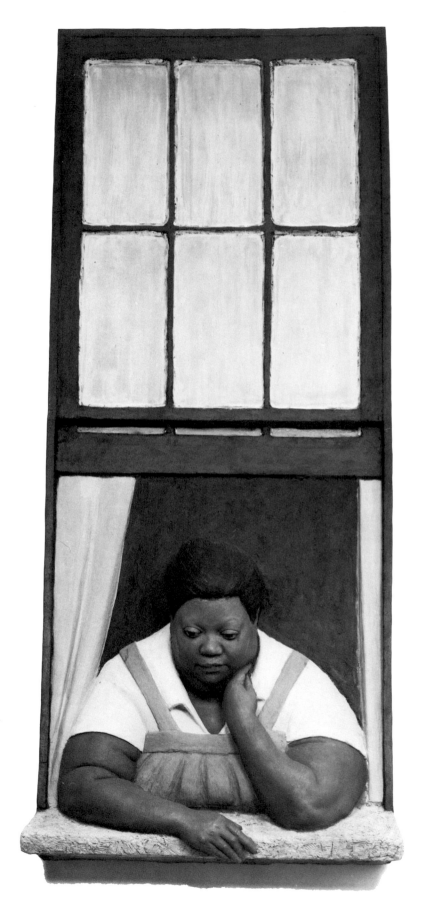

89. John Ahearn
Titi in Window 1985
Collection The Brooklyn Museum
87.194.1
Gift of Cheryl and Henry Welt
in memory of Abraham
Joseph Welt

A different version of this cast
is part of the *Back to School*
mural [fig. 92].

70

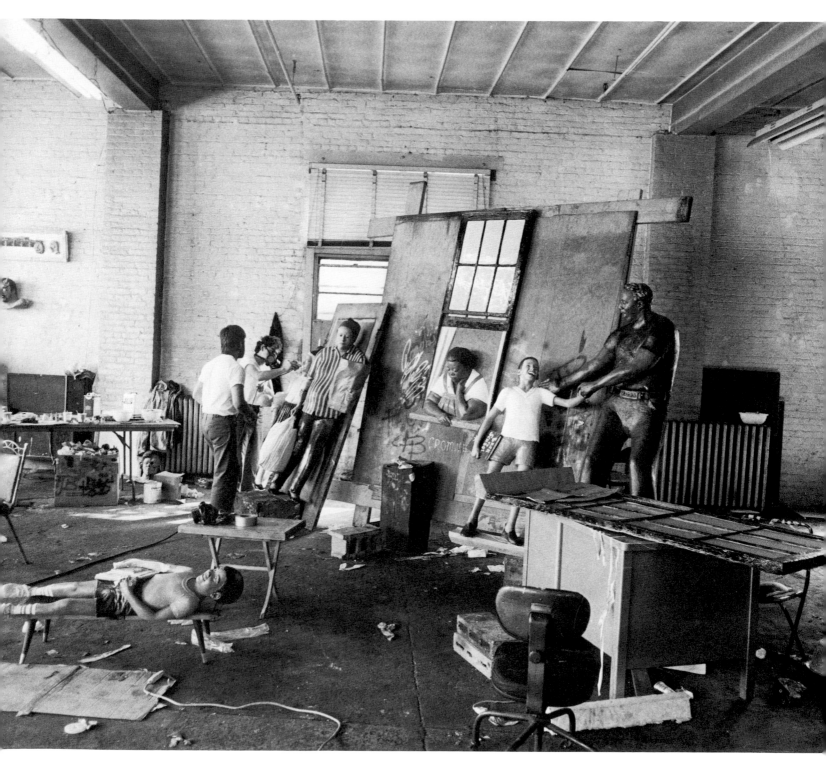

90. Studio garage near Walton Avenue: Ahearn [left] and
studio assistant Francisco Barragon working on casts for the
Back to School mural, 1985.

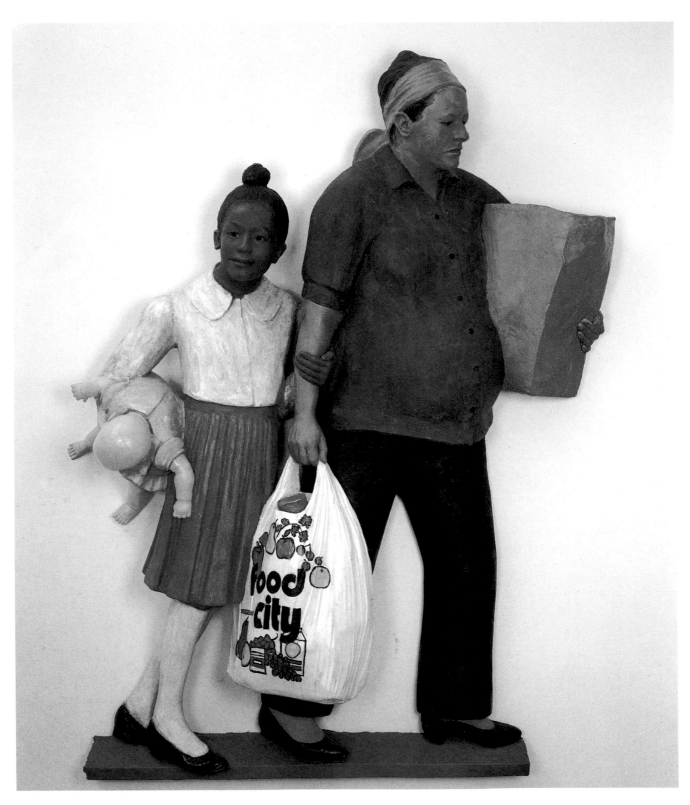

91. John Ahearn
Maggie and Connie 1985
Collection The Eli Broad Family Foundation, Santa Monica,
California

A different version of this cast is part of the *Back to School*
mural [fig. 92].

opposite:
92. John Ahearn and Rigoberto Torres
Back to School 1985 [cover]
170th Street at Walton Avenue, Bronx
photographed March 1991

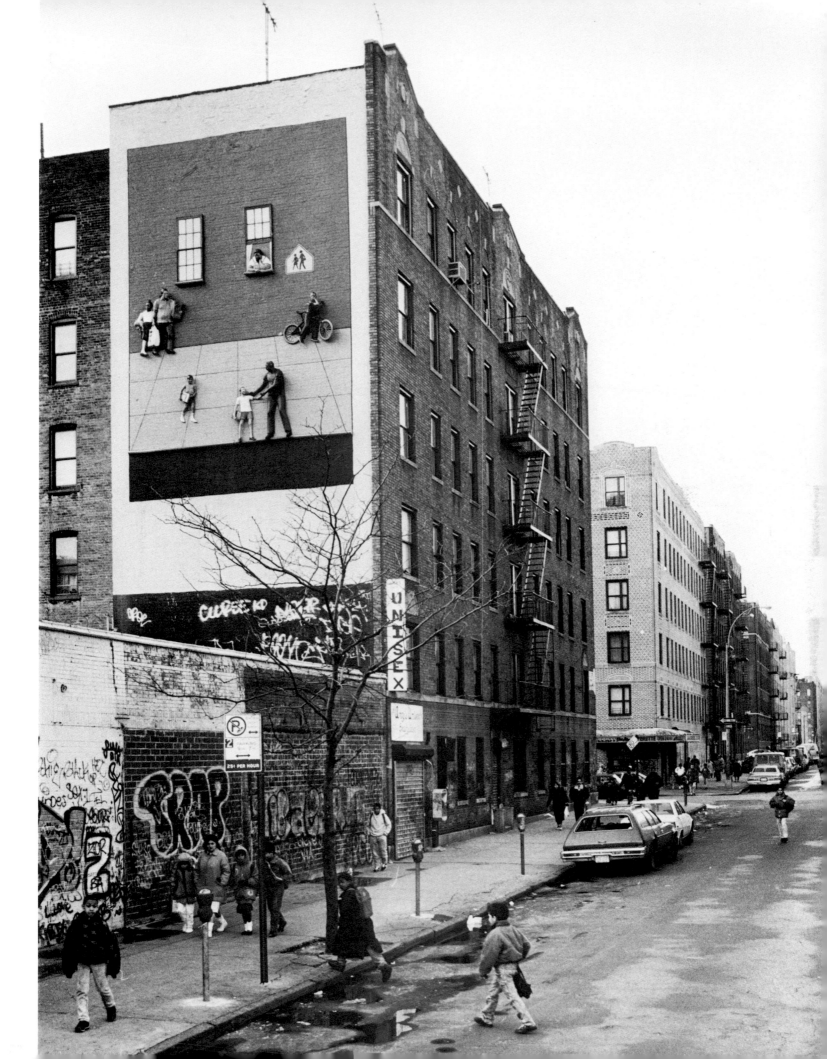

93. John Ahearn
Luis' Mother 1986
Collection Froma Eisenberg

Luis' mother is Zunilda Garcia [fig. 88].

opposite:
94. John Ahearn
Car Painter 1987
Collection Cheryl and Henry Welt

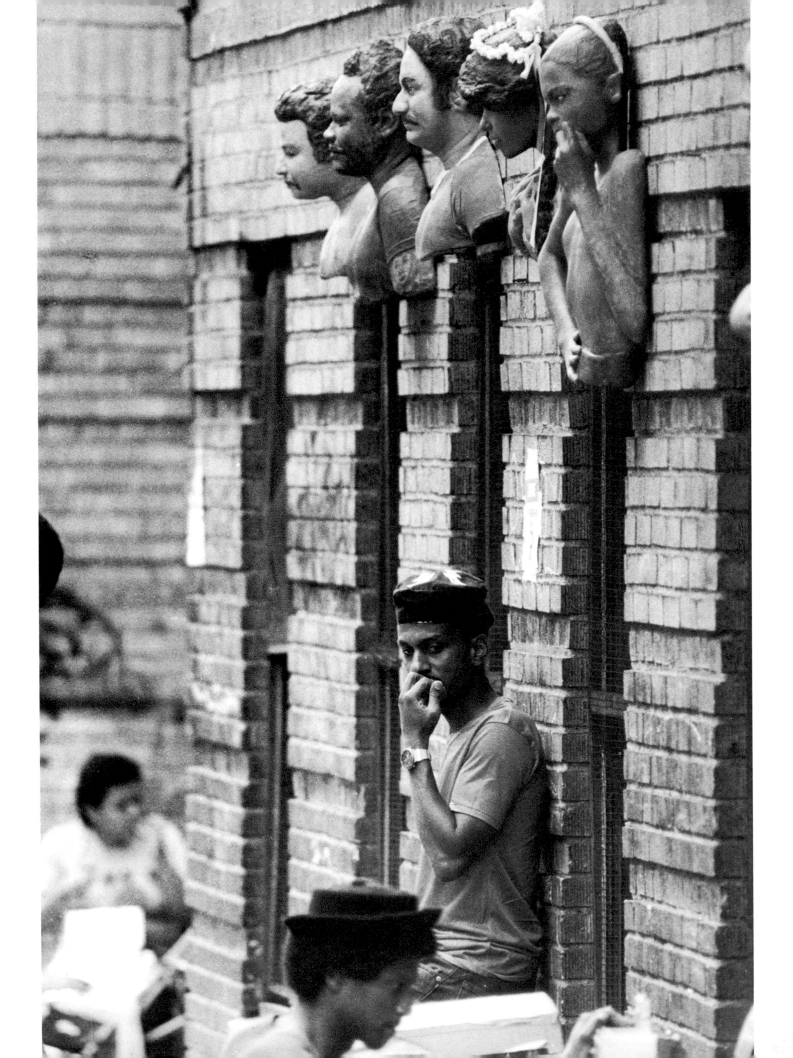

The Headhunters of Walton Avenue

RICHARD GOLDSTEIN

To most New Yorkers, the South Bronx is a black hole. It is the poorest congressional district in America, with half its mostly Hispanic population living below the poverty line. The quality of health care is comparable to what prevails in the Third World. Tuberculosis, syphilis, and AIDS are rampant, but there is only one private physician for every 4,000 residents. Lincoln Hospital, the major medical center in the area, has the city's most active maternity ward, and nearly 20 percent of the infants born there require intensive care.

Last year, police responded to about 600 violent crimes in a single South Bronx precinct. Many more assaults and rapes go unreported. The most sensational crimes make the papers; a 7-month-old baby left to die while his mother roamed the streets in search of crack was big news this spring. But the steady toll of lives lost to drugs and families torn apart by violence is too common to be noteworthy. In the hulks of nearly 500 abandoned buildings, the homeless squat and crack dealers roost. Kids scamper alongside them on many streets.

Walton Avenue and 170th Street is not a bad block, as the South Bronx goes. It is adjacent to a busy shopping street and not far from the Grand Concourse. Sturdy apartment houses still stand, and only when you enter these vast empty lobbies and climb the derelict marble stairs (the elevator no longer works), does the deprivation show. John Ahearn and Rigoberto Torres live on this block. From the roof of their building, you can see the sculpture mural they've installed on a high wall. Called *Back to School* (cover, fig. 92), it features people of all ages from the block playing, leaning out the window, and shopping for school clothes. "I wanted a bright, kiddy-book version of the neighborhood," Ahearn says. As they walk to school, students at P.S. 64 can see this carefree tableau. Unstated is the fact that their school is near the bottom in citywide reading scores, but the power of Ahearn's art is precisely in the contrast between what it projects and what the environment produces. To see these gamboling figures in an art gallery, hanging on what he calls "the wall of power," is to understand something about the vitality of children. But to see this work on the wall of poverty is to grasp the tragedy of the South Bronx.

On a warm Saturday in April 1991, John Ahearn leaves his top-floor apartment on Walton Avenue and heads down to the street, his dog, Summer, in tow. At home, where sculptures at every state of execution hang in odd places on the walls, he looks the obsessed artist, but on the block his shorn hair and jeans are only faintly exotic, and he enters the flow of small talk. In the courtyard, a red-headed woman in a bright print dress leans from her window, summoning the artist. A hairdresser by trade, Jackie Nunez (fig. 20) is concerned that her cast won't reflect her new do. "I'm doing every curl by hand," Ahearn protests. But Jackie is skeptical, unfamiliar with

95. Walton Avenue studio block party, 1985.

96. Raymond Garcia, 1990.

the laborious task of scalping a plaster head and updating it to suit. Like many residents of Walton Avenue, she sees Ahearn's art in terms of her mystique. And he spends much of his time keeping people's images in good repair.

Ahearn draws his subjects exclusively from among residents of the South Bronx, and it isn't always easy to get their cooperation. He sometimes spends months cajoling people into the casting process, sketching entire families, hanging out in people's apartments, suffering broken appointments. When he moved to Walton Avenue in 1980, Ahearn was known as "The Headhunter," and people thought sitting for him meant certain death. Things improved as his sculptures began to make an impact on the area, going up on bare brick tenement walls (in the summer, Ahearn hangs heads on Walton Avenue from pegs set into his building). The lure of being cast has become irresistible. "Everyone who said they wouldn't do it did," says Raymond Garcia (figs. 96, 98), who was cast with his pit bull, Toby, a famous fighter in the neighborhood. The dog stood for the cast (fig. 97), but Raymond had to be calmed down and redone several times. The experience reminded him of an incident in childhood when he almost drowned.

To be cast for an Ahearn sculpture, the subject must breathe through straws in the nostrils as a gel is brushed over the body, left to harden, and then peeled away. The resulting cast—rendered and painted by the artist from a series of Polaroids—is so lifelike that some people cross themselves when they first get a look. "I wouldn't have it in my house," says Raymond's brother, Freddy Garcia (fig. 109), who has also been cast. "It's like seeing yourself. Or if you have one of a person who passed away, it's like seeing the person. It's so real that it bothers you." During Ahearn's early days, one of his subjects walked into Fashion Moda, an artspace in the South Bronx, and ripped a bust of himself from the wall. He smashed it, yelling, "There can't be two of me! I'm the only one!"

Raymond, a volatile man in his early thirties, is glad he was cast, though he admits, "It bugs you at first. I think about when I get older, I'm gonna see myself, the pure image of what I looked like. To me, it's like being trapped." For the present, Raymond and his dog reside in the personal collection of Ed Downe and Charlotte Ford. Ahearn has a clipping from *Hamptons* magazine, showing summer guests cavorting around what is described as "the primitive art on Downe's wall."

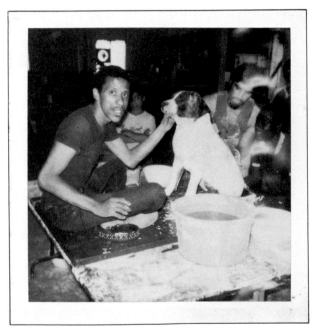

97. Garcia assisting with the cast of his dog, Toby, 1986.

opposite:
98. John Ahearn, *Raymond and Toby* 1986
Collection Edward R. Downe, Jr.

A bronze cast of this work is part of the *Bronx Sculpture Park* [fig. 131].

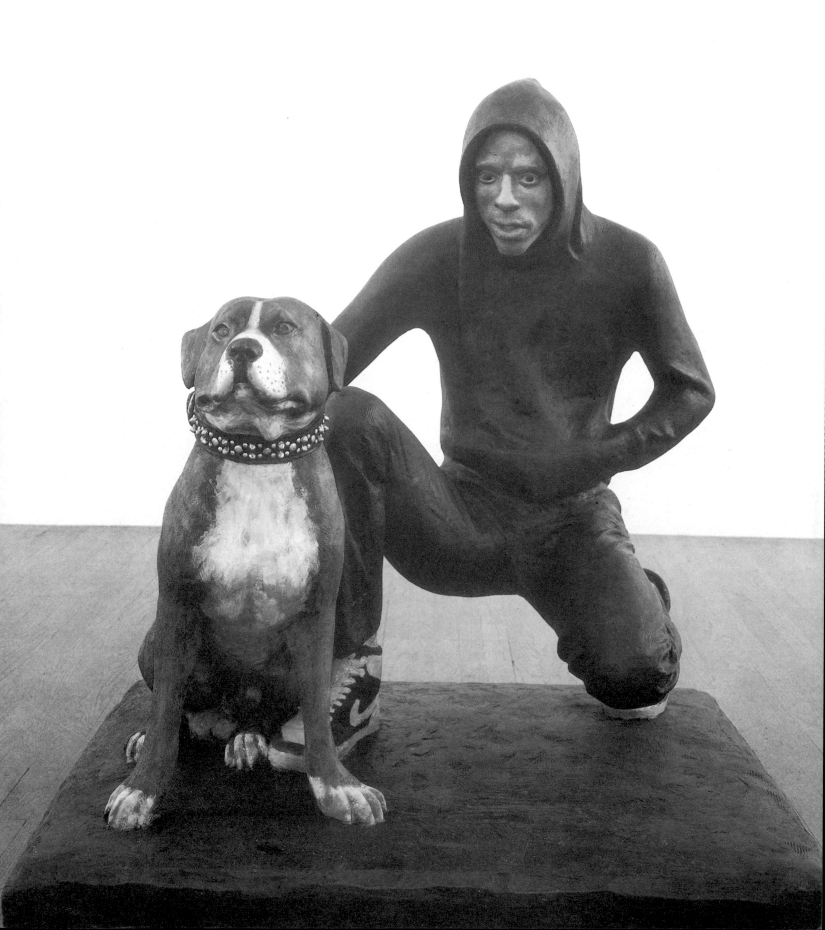

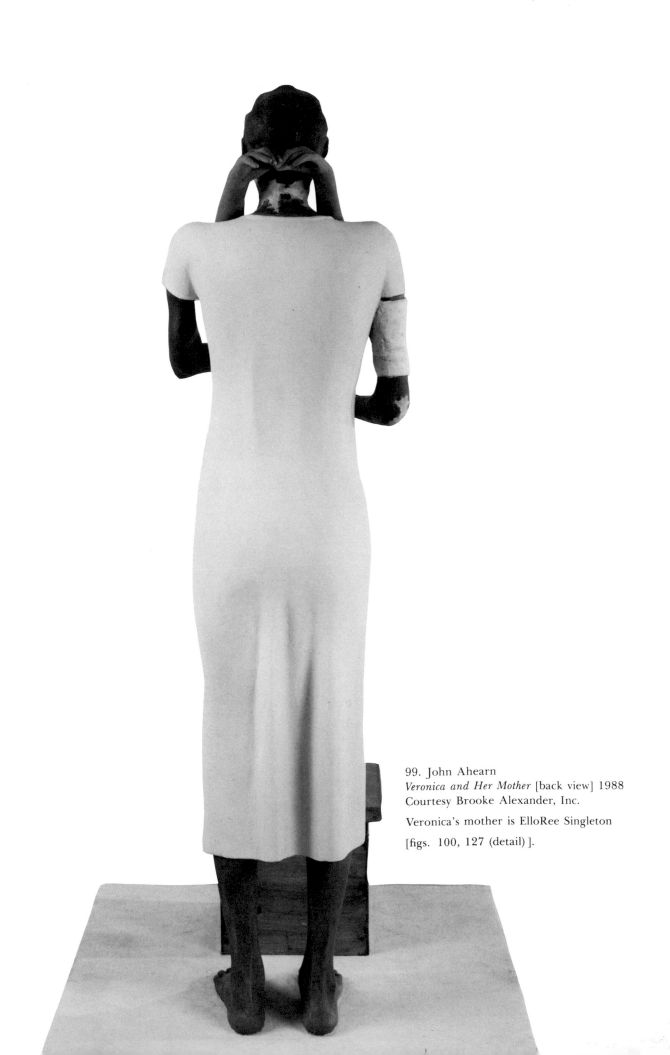

99. John Ahearn
Veronica and Her Mother [back view] 1988
Courtesy Brooke Alexander, Inc.

Veronica's mother is ElloRee Singleton

[figs. 100, 127 (detail)].

100. John Ahearn
ElloRee 1989
Courtesy Brooke Alexander, Inc.

(figs. 106, 107); Maria Fonseca, fresh out of Rikers (fig. 102); ElloRee Singleton (figs. 99, 100, 127), her daughter Veronica (figs. 99, 127), her son Corey (fig. 101), his friend Kevin Crocker, and all the "homeys" on the block. Everyone who agrees to be cast is entitled to a bust, and most of these heads end up on walls crowded with pictures of wide-eyed cats and grandchildren, track trophies and calendars from Chinese restaurants (figs. 79–88). "It adds class to my living room," says ElloRee, who was cast with her daughter three years ago, when Veronica was five. "I'm honored that John chose to represent me in his work,"

101. John Ahearn
Corey [back view] 1988 [not in exhibition]
Collection the artist
Corey is ElloRee Singleton's son. A bronze cast of this work is part of the *Bronx Sculpture Park* [fig. 131].

But Raymond is more interested in the bronze sculpture Ahearn plans to place in a vacant triangle near the elevated subway line (figs. 130–132). Raymond and the late great Toby will be part of it, a permanent fixture of the neighborhood. "I didn't think it would come this far," he says. "What did I do that was so great in this world that they're making me in bronze?" Raymond hopes to be present at the unveiling, "to christen it with a bottle of Ripple." But he adds, "Every time I think of it going up, I ask myself, will I be alive, or dead like my dog?"

Ahearn's art is an archive of lives that have rarely, if ever, been documented. Walking around the neighborhood, you can meet his entire oeuvre in the flesh: Orlando Perez, the donut man in the Munch Time restaurant (fig. 108); Bobbie Nazat, who makes her living sweeping the sidewalk

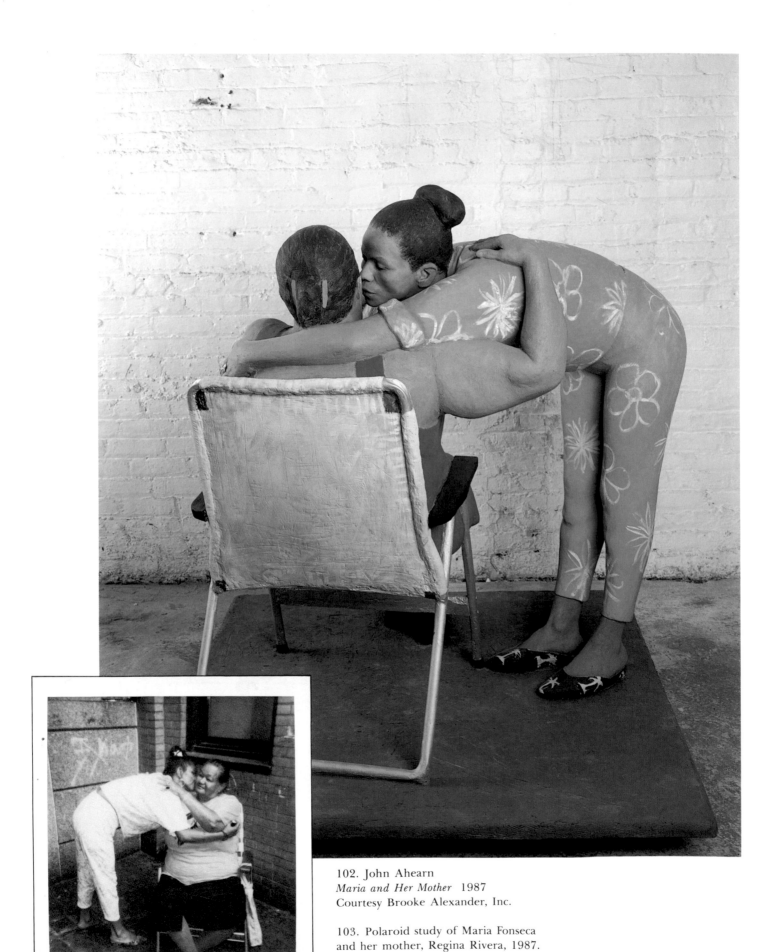

102. John Ahearn
Maria and Her Mother 1987
Courtesy Brooke Alexander, Inc.

103. Polaroid study of Maria Fonseca
and her mother, Regina Rivera, 1987.

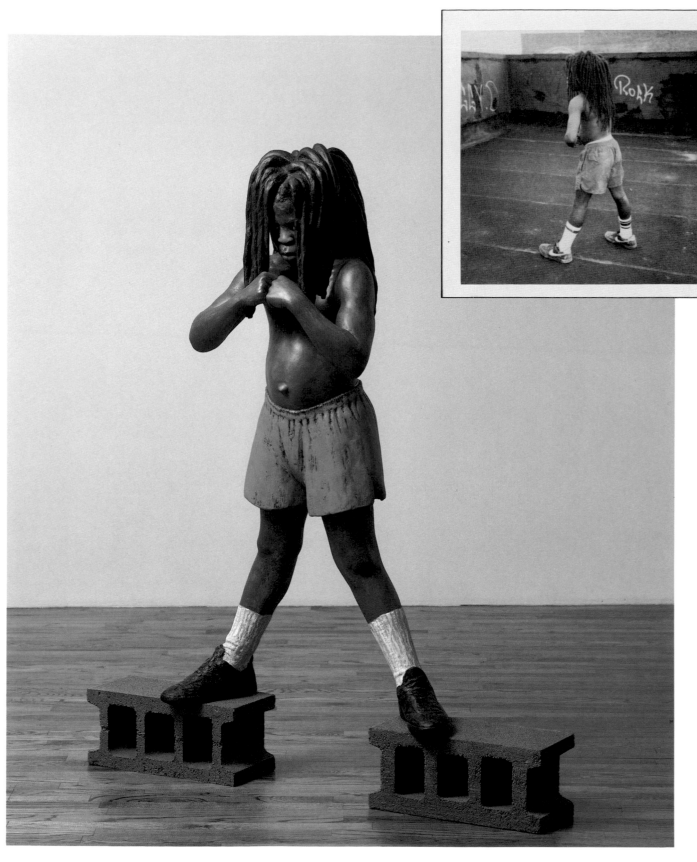

104. John Ahearn
Samson 1990
Collection The Eli Broad Family Foundation, Santa Monica, California

105. Polaroid study of Kenyatta Caldwell
[*Samson*], 1990.

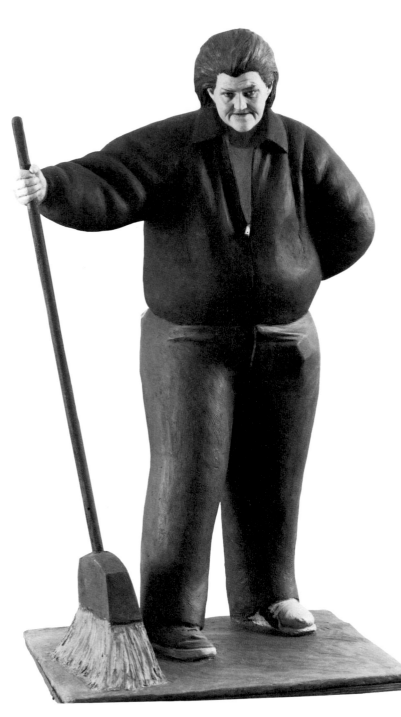

106. John Ahearn
Bobbie the Sweeper 1988
Courtesy Brooke Alexander, Inc.

she says playfully, and Ahearn banters back, "I'm honored that you're honored."

In the life-sized sculpture, Veronica stands on tiptoes with her arms thrown around ElloRee's neck (figs. 99, 127). In life, she is fully capable of interrupting her mother while simultaneously showering her with kisses. ElloRee, a thin but stately black woman of 39, has spent quite a bit of time in hospitals due to a degenerative condition that left her with gnarled hands and raw skin. Ahearn worried about how she would react to her statue, and he made a second, prettied-up version. But ElloRee chose the original; she wanted to be seen as she is. "For the first time, I had the opportunity to see myself as others see me," she says. "I saw strength and beauty, and I liked the smile I had. Because I'm a very happy person, regardless of all my imperfections. I don't worry about how I look, because when I get dressed up and put my makeup on, I look like a queen." She hopes the sculpture will sell, and she would be "honored if a rich person put it in their living room." But she would rather see it standing in the lobby of a hospital, where patients can see it. "Even when I'm gone," she says, "I would like to know that's something me and Veronica did together."

When they are viewed in a gallery, Ahearn's works are like life-sentries standing against the white walls and pale wood floors. At his exhibition openings, the residents of Walton Avenue sometimes show up to party (fig. 107). "I never met so many people in my life," says Bobbie, the sweeper (fig. 106), describing one such event. Ahearn's cast of her blunt face and husky frame now stands in the middle of Max Fish, an East Village art-bar. "Since he made me famous, lots of people come up to me like they know me. When I go on the subway and people stare at me, I wonder, did they see my statue?"

Despite her asthma and spinal deterioration, Bobbie starts sweeping the sidewalks on 170th Street at six every morning, sometimes after spending the night at Munch Time ("My second home," she says). "I don't like to see the street dirty, so I make sure it's clean, even if I'm not supposed to." At 51, she makes her living from small donations from merchants and cops. And

Bobbie writes poetry. She sends her verses to mail-order writing schools and once was offered the chance to compete for a trophy with her name on it, but she couldn't afford the registration fee. She keeps a picture of herself, standing with her statue, in her room. "I look at that every night," says Bobbie. "If anything were to go wrong and I'm not around," she hopes they will place her statue on the block, "so everybody can see who was the sweeper on 170th Street."

From the start, Ahearn's project in the South Bronx has been a collaboration with Rigoberto Torres. A native of Puerto Rico, Torres grew up in the neighborhood, an asthmatic child who liked to tinker with cars and "invent things." In 1979 a cousin driving a gypsy cab happened to pass by Fashion Moda and saw something he thought Robert (as most people call Rigoberto) would be interested in: these weird heads. They were painted casts of Ahearn's downtown friends, and when Torres saw them, he wanted in. At age 18, he was "this ideal young man," says Ahearn, "very high-energy, but always sensitive to the idea of a given situation." Torres took his new friend to his Uncle Raul's religious art factory (fig. 66), where he once worked painting blue eyes and open wounds on martyrs. Soon, he was Ahearn's apprentice, and it was Torres who came up with the idea of casting people on the

108. Munch Time Restaurant with Orlando Perez standing beside Torres' *Orlando the Donut Man*, 1987.

block. After the *Times Square Show* in 1980, Torres convinced Ahearn to leave the East Village for an apartment on Walton Avenue. They still live in the same building—the Torres family in several apartments, and Ahearn on the top floor.

Though they sometimes work together, the two artists have evolved very different attitudes toward color and form. Ahearn's heads are intense and mottled; Torres' are grand and benign. His life-sized statue of three boys sitting on each other's shoulders, as if they have just come out from under the hydrants on a hot afternoon, looks like a totem pole (fig. 112). ("These kids are my new family," Torres explains. "I did it to get close to them.") Torres uses a single flesh-tone; he doesn't share Ahearn's interest in patches of "green and blue and all kinds of weird colors on the face. John creates more of that suffering in the paint. My way of doing it is, I gotta have some happiness."

He and Ahearn share a studio on a dead-end street where dogs cavort and men work on cars or wander aimlessly. Today, Torres is working on a statue of Ruth Fernandez, a salsa singer who lives in Puerto Rico (fig. 129). She stands at a show-

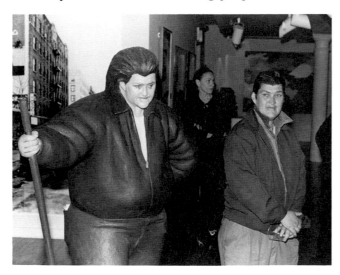

107. Bobbie Nazat with *Bobbie the Sweeper* at opening of exhibition, *The Decade Show*, The Studio Museum in Harlem, 1990.

stopping moment, her arms thrust out, wearing a black gown affixed with jewels. Torres hopes to do a similar sculpture of salsa-vixen Iris Chacon, and one of Walter Mercado, who reads horoscopes in a cape and swept-back hair on Spanish-language TV. Would he like to see his work in the Whitney Museum? "I been there," Torres says. "Being on TV—that's a little better."

He can see himself at 50 supervising an atelier of South Bronx artisans, like his Uncle Raul. For now, though, he is working late every night, preparing for his first one-person exhibition, in Spain. "This is my lucky year, I call it. You saw me in the gallery, like a mad person, creating something that doesn't exist. Life."

They have made casts of each other, Ahearn painting his friend in a mustardy hue (fig. 32). "I never liked it too much," Torres says. He reciprocated with a bust of Ahearn (fig. 1) that "made me look wacky and goofy, not street-cool or anything." Ahearn has had some hard times in the Bronx. One of his subjects broke into the apartment, and a window is now boarded

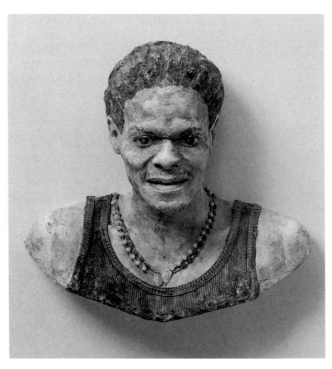

109. John Ahearn
Freddy 1989
Courtesy Brooke Alexander, Inc.

Freddy is Raymond Garcia's brother [fig. 98].

up to prevent a return visit. Many of his stolen belongings reside in a crack den, waiting for Ahearn to buy them back. There have been emotional entanglements and battles. "I think the number-one personal problem is, what right do I have as a white person to represent a black or Hispanic person?" Ahearn says. When we met, he was repairing broken pieces of religious statuary for people on the block.

Ahearn was raised a Catholic in Binghamton, New York, and I wondered whether that might be a hidden link between him and this community. Ahearn's role in the neighborhood does have a certain pastoral quality. He spends much of his time visiting once and future subjects, and casting their image is part of the process of getting to know them as intimately as possible. "I'm a regular, mediocre, middle-class guy," he says. "So this is my opportunity to have my own fantasy, and everyone else gets taken along for the ride." His art, at this point, is utterly dependent on an intricate interplay with the people around him. "I tend to vibrate between thinking it's my work and it's a collaboration with the subject," Ahearn says. He concludes, "I'm a major element of the work, but I'm not the work."

He is drawn, for whatever reasons, to people who must cope with suffering, and in this neighborhood, they are everywhere. "Do you know Saint Lazaro?" he asks. "I always wanted to do a statue of him." Then he found the perfect Lazaro (fig. 110), the 23-year-old who had broken into his apartment. "He was one of the first kids on the block to go down from crack," Ahearn recalls. Working from a photo taken of "Lazaro" while he was recovering in the hospital after being thrown from the roof of a five-story building, Ahearn cast him in a hospital gown. A bandage is wrapped around much of his body; the exposed flesh is covered with sores. This is not the Saint Lazaro they replicate in Raul's religious art factory, a beatific figure on crutches with dogs lapping at his feet. This Lazaro is a pleading, scowling man, his body swollen, trapped in his situation. His image assaults you from the gallery wall. Ahearn's *Lazaro* is the face of suffering without apology. The patron saint of the South Bronx.

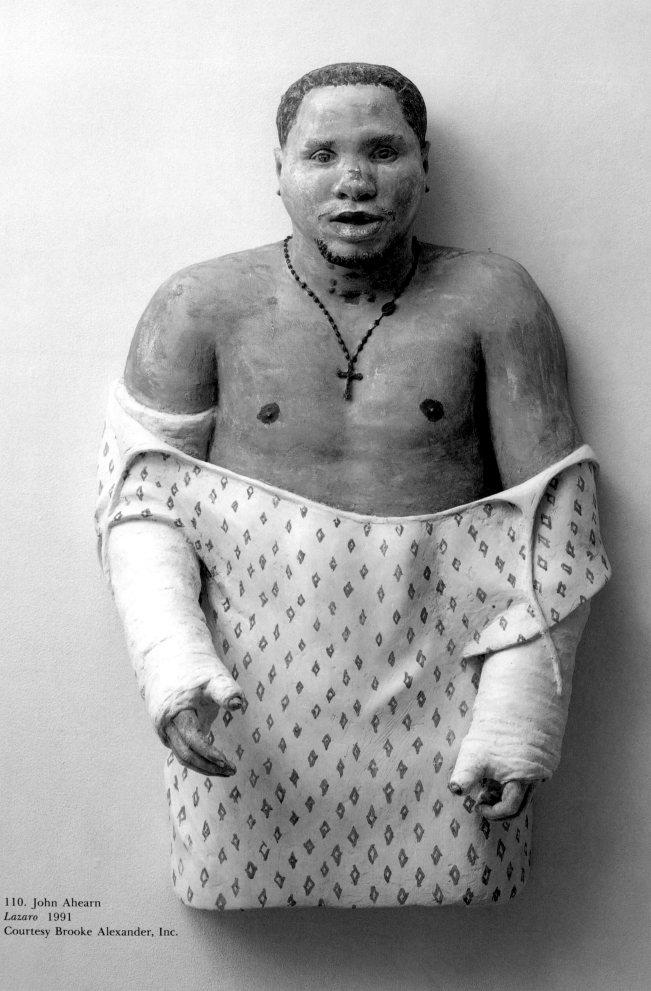

110. John Ahearn
Lazaro 1991
Courtesy Brooke Alexander, Inc.

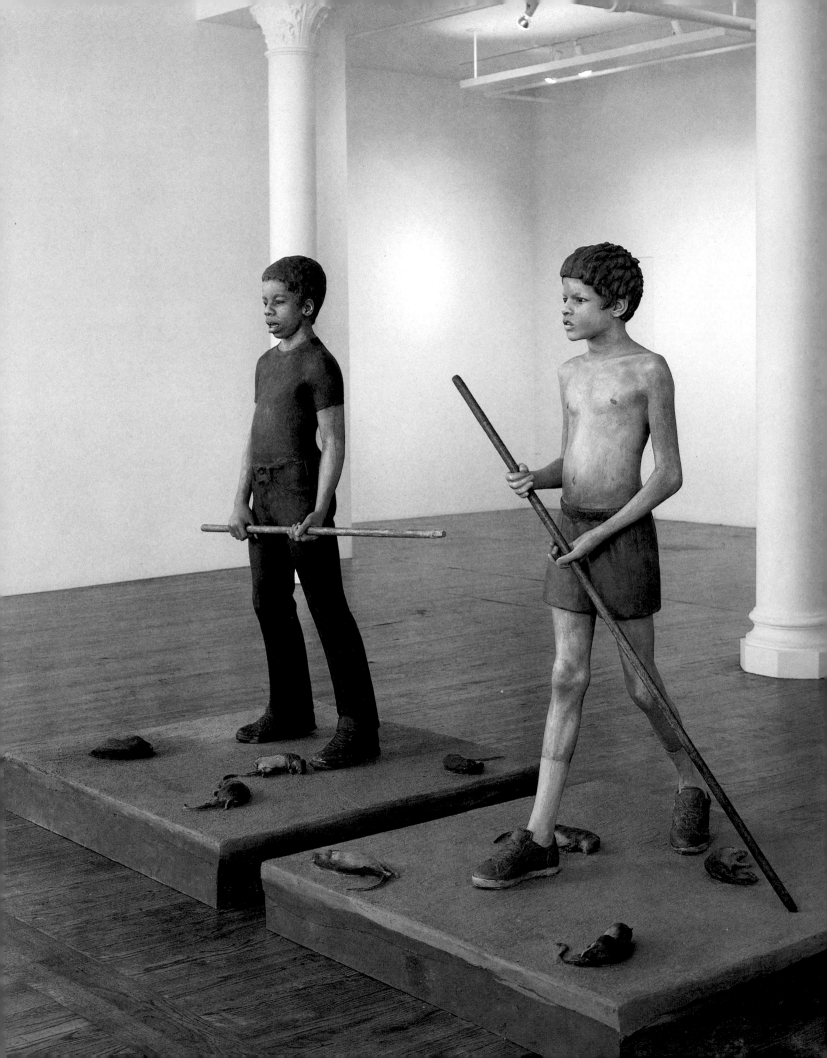

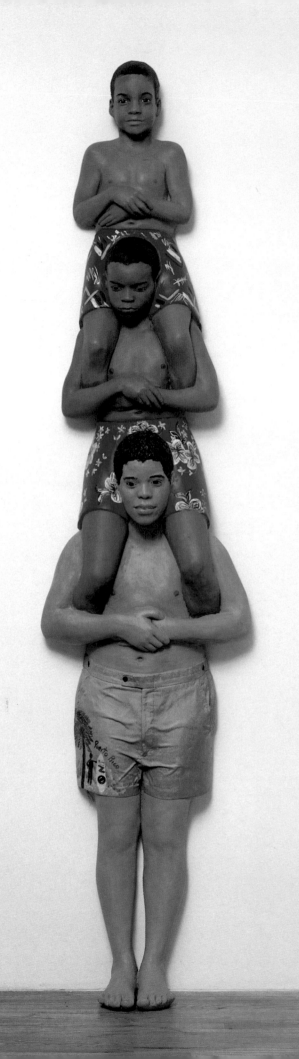

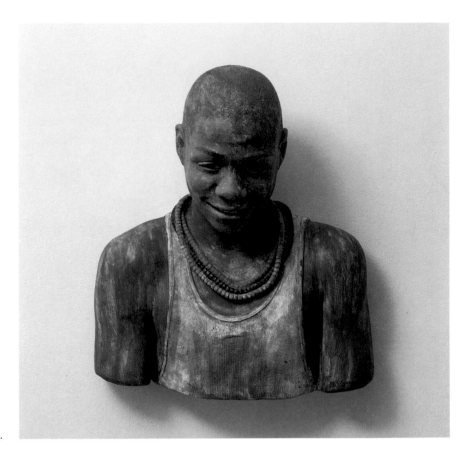

113. John Ahearn
Stefan 1990
Courtesy Brooke Alexander, Inc.

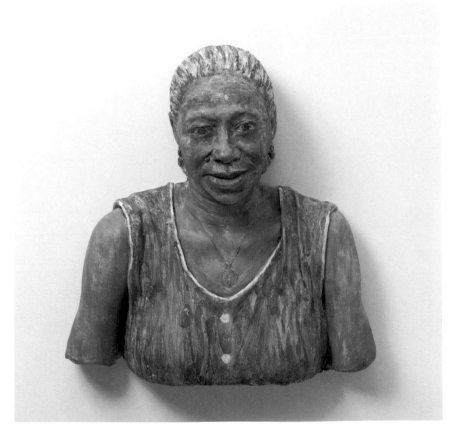

114. John Ahearn
Titi Concha 1989
Courtesy Brooke Alexander, Inc.

Concha is Raymond and Freddy
Garcia's aunt [figs. 97, 109].

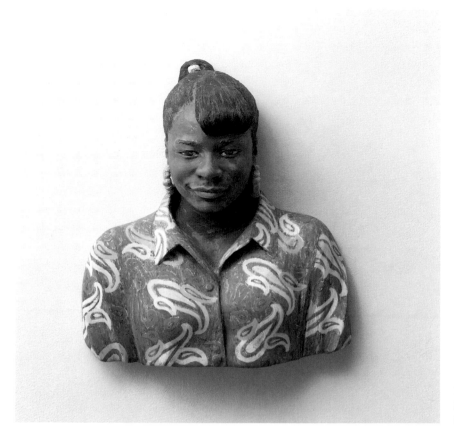

115. John Ahearn
Nikki 1991
Collection the artist

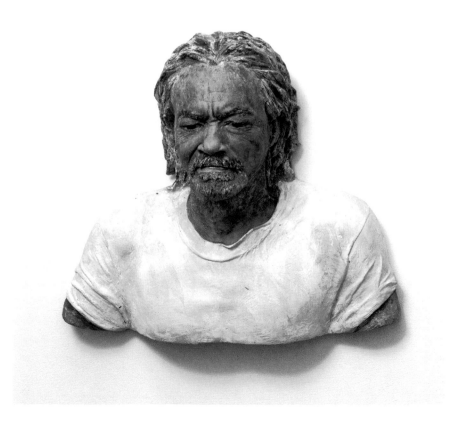

116. John Ahearn
Pops – Indian Bill 1989
[not in exhibition]
Collection Mr. and Mrs. Leon Fassler

A different version of this cast, entitled
Willie Moore, is included in the exhibition.
Pops is Nikki Ubiera's great-grandfather.

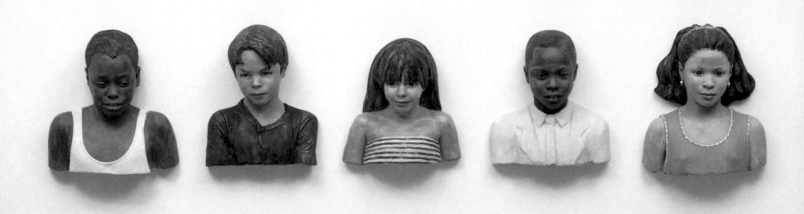

John Ahearn [left to right]

117. *Nacor Castillo* 1990
[not in exhibition]
Courtesy Brooke Alexander, Inc.

118. *Junito* 1989
[not in exhibition]
Collection Mr. and Mrs. Leon Fassler

119. *Zuhey* 1989
Collection Kempf Hogan

120. *Tico in Wedding Suit* 1989
Collection Tom Otterness

121. *Claribel* 1990
Courtesy Brooke Alexander, Inc.

opposite:
122. John Ahearn
Takiya 1990
Courtesy Brooke Alexander, Inc.

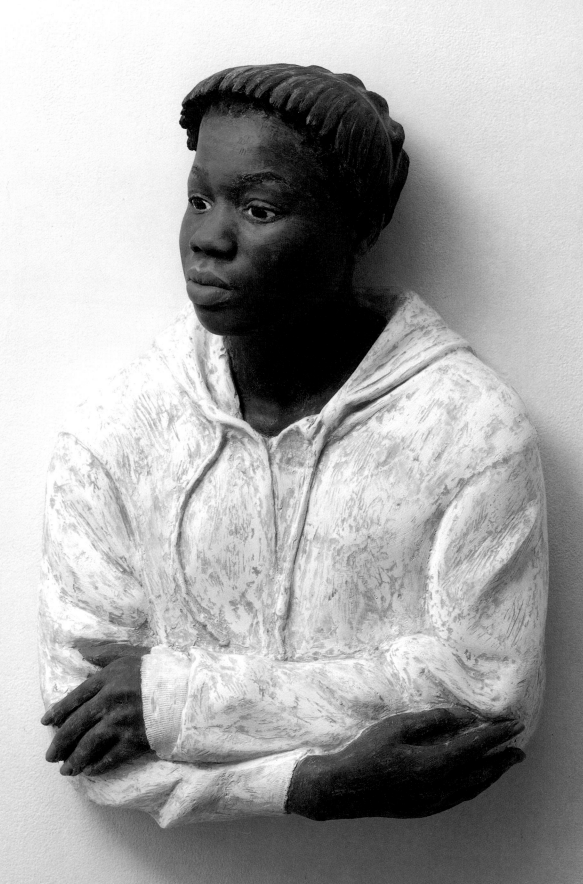

Catalogue to the Exhibition

On occasion, the artists make different versions of a cast, such as one for the model or one for a public wall mural. Dates with a slash indicate date of the first cast / date of listed cast.

Reproductions of works in the exhibition are indicated by *fig. no.* Reproductions of different versions of works in the exhibition are indicated by *see fig. no.*

Dimensions are given in inches followed by centimeters: height precedes width precedes depth.

Fashion Moda: 1979

All seventeen works in this section are acrylic on cast plaster and were included in the *South Bronx Hall of Fame* exhibition at Fashion Moda.

The following thirteen works:
John Ahearn
Collection the artist

Big City 1979 fig. 19
14 by 13 by 8 inches (36 by 33 by 20 cm)

Butch and Earl 1979 fig. 18
33 by 18 by 10 inches (84 by 46 by 25 cm)

David Ortiz (laughing) 1979 fig. 21
14 by 14 by 7 inches (36 by 36 by 18 cm)

David (with scar) 1979 fig. 27
15 by 9½ by 5¼ inches (38 by 24 by 13 cm)

Greek Head 1979 fig. 16
14 by 10 by 7 inches (36 by 25 by 18 cm)

Janice Parsons 1979 fig. 14
15 by 12 by 7 inches (38 by 31 by 18 cm)

Johnny 1979 fig. 13
16 by 12 by 6 inches (41 by 31 by 15 cm)

Mario and Norma 1979 fig. 26
23 by 17 by 8 inches (58 by 43 by 20 cm)

Pregnant Girl 1979 fig. 15
14 by 10 by 7¼ inches (36 by 18 by 18 cm)

Robert 1979 fig. 22
15 by 16 by 9 inches (38 by 41 by 23 cm)

Sandy 1979 fig. 17
12 by 8 by 6½ inches (30 by 20 by 17 cm)

Willy Neal 1979 fig. 25
15 by 15 by 8 inches (38 by 38 by 20 cm)

Young Lord 1979
14 by 8 by 6½ inches (36 by 20 by 17 cm)

John Ahearn
Carlos 1979 fig. 12
15 by 18 by 9½ inches (38 by 46 by 24 cm)
Collection Lannan Foundation, Los Angeles

John Ahearn
Luis Fuento 1979
15½ by 14½ by 9½ inches (40 by 37 by 24 cm)
University of South Florida Collection. Purchased 1984 with funds provided by Florida's Art in State Buildings Program. Courtesy the USF Art Museum.

Rigoberto Torres
Shirley 1979 fig. 23
13 by 13 by 5 inches (33 by 33 by 13 cm)
Collection John Ahearn

John Ahearn
Yvonne and Maria, Two Girls Laughing 1979 fig. 34
23 by 17 by 8 inches (58 by 43 by 20 cm)
Collection The Chase Manhattan Bank, N.A.

Walton Avenue: 1980-81

Rigoberto Torres with **John Ahearn**
Boxer 1980 fig. 33
acrylic on cast plaster
21 by 21 by 9 inches (53 by 53 by 23cm)
Collection William and Norma Roth

John Ahearn
Luis and Virginia Arroyo 1980 fig. 42
acrylic on cast plaster
24 by 24½ by 7 inches (61 by 62 by 18 cm)
Collection the artist

John Ahearn
Luis with Bite in Forehead 1980 fig. 41
acrylic on cast plaster
24 by 21 by 6 inches (61 by 53 by 15 cm)
Collection The Museum of Contemporary Art,
Los Angeles, The Barry Lowen Collection

John Ahearn
Bernice 1981 fig. 39
acrylic on cast plaster
28½ by 27 by 6 inches (72 by 68 by 15 cm)
Collection The Metropolitan Museum of Art, Gift of
Barbara and Eugene Schwartz, 1988 (1988.417.4 III)

John Ahearn
Boobie (Sneakertown U.S.A.) 1981 fig. 45
acrylic on cast plaster
25 by 23 by 7 inches (64 by 58 by 18 cm)
Rubell Family Collection

John Ahearn
Esther (in the sixth grade) 1981 fig. 46
acrylic on cast plaster
25 by 26 by 6 inches (64 by 66 by 15 cm)
Collection the artist

John Ahearn
Maria (laughing) 1981 fig. 40
acrylic on cast plaster
24 by 16 by 7½ inches (61 by 41 by 19 cm)
Collection Lannan Foundation, Los Angeles

John Ahearn
Migna 1981 fig. 38
acrylic on cast plaster
18 by 28 by 10 inches (46 by 71 by 25 cm)
Rubell Family Collection

Dawson Street: 1981-83

John Ahearn
Clyde (blue version) 1981 fig. 62
acrylic on cast plaster
26 by 25 by 9 inches (66 by 64 by 23 cm)
Collection Lannan Foundation, Los Angeles

John Ahearn
Tawana and Staice 1981/87 see fig. 50
oil on fiberglass
16 by 27 by 8 inches (41 by 69 by 20 cm)
Collection Cheryl and Henry Welt

John Ahearn
Homage to the People of the Bronx: see figs. 47, 65
Double Dutch on Kelly Street I 1981–82
oil on fiberglass
54 by 154 by 12 inches (137 by 391 by 30 cm)
Collection The Eli Broad Family Foundation,
Santa Monica, California

John Ahearn
Andrea 1982 fig. 53
acrylic on cast plaster
23 by 17 by 6½ inches (58 by 43 by 17 cm)
Collection Susan and Lewis Manilow

John Ahearn
Charlie I 1982 fig. 63
acrylic on cast plaster
26½ by 17¾ by 8½ inches (67 by 45 by 22 cm)
Collection the artist

John Ahearn
Duane and Al 1982 fig. 64
acrylic on cast plaster
33 by 32 by 10 inches (84 by 81 by 25 cm)
Collection Munira Nusseibeh and Francisco Hernandez

John Ahearn
El Pirata 1982 fig. 52
acrylic on cast plaster
28½ by 18½ by 8½ inches (72 by 47 by 22 cm)
Collection Susan and Lewis Manilow

John Ahearn
Kate 1982 fig. 49
acrylic on cast plaster
26 by 27 by 9 inches (61 by 69 by 15 cm)
Collection the artist

John Ahearn
Victor and Ernest 1982 fig. 48
acrylic on cast plaster
24 by 22 by 9 inches (61 by 56 by 23 cm)
Collection The Foundation to Life, Inc.

Rigoberto Torres
Dixie 1982–83 fig. 56
acrylic on cast plaster
21 by 41 by 9 inches (53 by 104 by 23 cm)
Collection William and Norma Roth

Rigoberto Torres
Girl with Red Halter Top 1982–83 fig. 57
acrylic on cast plaster
22 by 16 by 8 inches (56 by 41 by 20 cm)
Collection Brooke and Carolyn Alexander

Rigoberto Torres
Manny the Magician 1982–83 fig. 68
acrylic on cast plaster with sword
25 by 25 by 14 inches (64 by 64 by 36 cm)
Collection Lannan Foundation, Los Angeles

John Ahearn
Janel and Audrey 1983 fig. 61
acrylic on cast plaster
32 by 32 by 9 inches (81 by 81 by 23 cm)
Collection Brooke and Carolyn Alexander

John Ahearn
Janice "Peanut" Harvey 1983 fig. 55
acrylic on cast plaster
34½ by 21 by 9 inches (88 by 53 by 23 cm)
Collection Edward R. Downe, Jr.

John Ahearn
Kassim 1983 fig. 54
acrylic on cast plaster
34 by 20 by 9 inches (87 by 51 by 23 cm)
Collection William and Norma Roth

John Ahearn
Pat and Selena at Play 1983 see fig. 75
oil on reinforced plaster
63 by 38 by 8 inches (160 by 97 by 20 cm)
Collection the artist

John Ahearn
Thomas 1983 fig. 76
oil on cast plaster
46 by 29 by 7 inches (117 by 74 by 18 cm)
Collection The Eli Broad Family Foundation,
Santa Monica, California

John Ahearn
Pedro with Tire 1982/1984 fig. 71
oil on reinforced plaster
80 by 42 by 18 inches (203 by 107 by 46 cm)
Collection Edward R. Downe, Jr.

John Ahearn
Barbara (for Ethiopia) 1982/1985 fig. 72
oil on reinforced polyadam and wood
84 by 36 by 20 inches (213 by 91 by 51 cm)
Collection Edward R. Downe, Jr.

Rigoberto Torres
Uncle Tito at the Liquor Store 1983/1985 fig. 70
acrylic on cast plaster
48 by 48 by 14 inches (122 by 122 by 36 cm)
Collection John Ahearn

Walton Avenue: 1983-91

John Ahearn
Wilma 1983
acrylic on plaster
20 by 20 by 9 inches (51 by 51 by 23 cm)
Collection the artist

Rigoberto Torres
Mabrick 1984 fig. 69
acrylic on cast plaster
32 by 30 by 9 inches (81 by 76 by 23 cm)
Collection William and Norma Roth

John Ahearn
Trudy 1984 fig. 78
oil on cast plaster
22 by 17 by 10 inches (56 by 43 by 25 cm)
Collection Milwaukee Art Museum
Given in memory of Josephine Segel by Jill and
William Feldstein, Sidney and Dorothy Kohl,
Kenneth and Audrey Ross, and Carole and
Bernard J. Sampson

John Ahearn
Jay with Bike 1985 see cover, fig. 92
oil on fiberglass
52 by 55 by 16 inches (132 by 140 by 41 cm)
Collection The Eli Broad Family Foundation,
Santa Monica, California

John Ahearn
Maggie and Connie 1985 fig. 91
oil on reinforced plaster
68 by 55 by 18 inches (173 by 140 by 46 cm)
Collection The Eli Broad Family Foundation,
Santa Monica, California

Rigoberto Torres
*Shorty Working in the C & R Statuary
Corporation* 1985 fig. 67
acrylic on cast plaster
27 by 22 by 18 inches (69 by 56 by 46 cm)
Collection John Ahearn

John Ahearn
Titi in Window 1985 fig. 89
oil on reinforced plaster
72 by 30 by 12 inches (183 by 76 by 31 cm)
Collection The Brooklyn Museum 87.194.1
Gift of Cheryl and Henry Welt in memory of
Abraham Joseph Welt

John Ahearn
Evie and Hazel in Conversation 1986 see fig. 133
oil on fiberglass
66 by 23¾ by 27 inches (168 by 60 by 69 cm)
Collection The Brooklyn Museum 87.194.2a-b
Gift of Cheryl and Henry Welt in memory of
Abraham Joseph Welt

John Ahearn
Luis' Mother 1986 fig. 93
oil on cast plaster
30 by 18 by 8 inches (76 by 46 by 20 cm)
Collection Froma Eisenberg

John Ahearn
Rat Killers 1986 fig. 111
oil on fiberglass in two parts
66 by 47½ by 47½ inches and 67½ by 56½ by 47½ inches
(168 by 121 by 121 cm and 171 by 144 by 121 cm)
Courtesy Brooke Alexander, Inc.

John Ahearn
Raymond and Toby 1986 fig. 98
oil on fiberglass
47 by 43 by 39 inches (119 by 109 by 99 cm)
Collection Edward R. Downe, Jr.

John Ahearn
Car Painter 1987 fig. 94
oil on reinforced polyadam
42 by 30 by 12 inches (107 by 76 by 31 cm)
Collection Cheryl and Henry Welt

John Ahearn
Jay 1987
acrylic on cast plaster
26 by 19 by 81/2 inches (66 by 48 by 22 cm)
Collection The Honolulu Advertiser

John Ahearn
Maria and Her Mother 1987 fig. 102
oil on fiberglass
51 by 52 by 48 inches (132 by 132 by 123 cm)
Courtesy Brooke Alexander, Inc.

John Ahearn
Bobbie the Sweeper 1988 fig. 106
oil on reinforced plaster
70 by 40 by 37 inches (178 by 102 by 94 cm)
Courtesy Brooke Alexander, Inc.

John Ahearn
Veronica and Her Mother 1988 figs. 99, 127
oil on fiberglass on wood
71 by 35½ by 35½ inches (180 by 90 by 90 cm)
Courtesy Brooke Alexander, Inc.

John Ahearn
ElloRee 1989 fig. 100
acrylic on cast plaster
39 by 25½ by 9 inches (99 by 65 by 23 cm)
Courtesy Brooke Alexander, Inc.

John Ahearn
Freddy 1989 fig. 109
acrylic on cast plaster
17 by 19 by 8 inches (43 by 48 by 20 cm)
Courtesy Brooke Alexander, Inc.

John Ahearn
Kenyatta Boxer 1989
acrylic on cast plaster
39 by 19 by 6 inches (99 by 48 by 15 cm)
Collection Kempf Hogan

John Ahearn
Willie Moore 1989 see fig. 116
acrylic on cast plaster
24 by 19 by 8½ inches (61 by 48 by 22 cm)
Collection the artist

John Ahearn
Tico in Wedding Suit 1989 fig. 120
acrylic on cast plaster
17½ by 15 by 7 inches (44 by 38 by 18 cm)
Collection Tom Otterness

John Ahearn
Zuhey 1989 fig. 119
acrylic on cast plaster
14 by 14 by 6½ inches (36 by 36 by 17 cm)
Collection Kempf Hogan

John Ahearn
Claribel 1990 fig. 121
acrylic on cast plaster
18 by 15 by 6 inches (46 by 38 by 15 cm)
Courtesy Brooke Alexander, Inc.

John Ahearn
Stefan 1990 fig. 113
acrylic on cast plaster
21 by 17¼ by 7 inches (53 by 43 by 18 cm)
Courtesy Brooke Alexander, Inc.

John Ahearn
Takiya 1990 fig. 122
acrylic on cast plaster
25 by 18 by 7½ inches (64 by 46 by 19 cm)
Courtesy Brooke Alexander, Inc.

John Ahearn
Titi Concha 1989 fig. 114
acrylic on cast plaster
20 by 20 by 8 inches (51 by 51 by 20 cm)
Courtesy Brooke Alexander, Inc.

John Ahearn
Samson 1990 fig. 104
oil on fiberglass
60½ by 50¾ by 15 inches (154 by 131 by 38 cm)
Collection The Eli Broad Family Foundation,
Santa Monica, California

Rigoberto Torres
Julio, Jose, Junito 1991 fig. 112
oil on fiberglass
105 by 26 by 9½ inches (267 by 66 by 24 cm)
Collection Mr. and Mrs. Herbert Levitt

John Ahearn
Lazaro 1991 fig. 110
acrylic on cast plaster
39 by 24 by 11 inches (99 by 61 by 28 cm)
Courtesy Brooke Alexander, Inc.

John Ahearn
Nikki 1991 fig. 115
acrylic on cast plaster
22 by 19 by 7½ inches (56 by 49 by 19 cm)
Collection the artist

Biographies

JOHN AHEARN

Born
Binghamton, New York, 1951

Education
B.F.A., Cornell University, Ithaca, New York, 1973

Selected Individual Exhibitions

1979 *South Bronx Hall of Fame.* Fashion Moda, Bronx, New York

South Bronx Hall of Fame. The Con Edison Building, Bronx, New York

1982 *John Ahearn.* Galerie Rudolf Zwirner, Cologne

1983 *John Ahearn with Rigoberto Torres: Recent Sculpture from Dawson Street.* Brooke Alexander, New York

1984 *John Ahearn with Rigoberto Torres.* Brooke Alexander, New York

1985 *John Ahearn and Rigoberto Torres – Portraits from the Bronx: Life Casts from 1979 to the Present.* The Bronx Museum of the Arts, Bronx, New York

INVESTIGATIONS: John Ahearn with Rigoberto Torres: Sculpture. Institute of Contemporary Art, University of Pennsylvania, Philadelphia

1986 *John Ahearn with Rigoberto Torres.* Brooke Alexander, New York

1988 *John Ahearn.* Brooke Alexander, New York

1990 *John Ahearn.* The Nelson-Atkins Museum of Art, Kansas City, Missouri

1991 *John Ahearn: Sculpture 1988-91.* Brooke Alexander, New York

South Bronx Hall of Fame: Sculpture by John Ahearn and Rigoberto Torres. Contemporary Arts Museum, Houston (traveling to Witte de With, Rotterdam; The Contemporary Arts Center, Cincinnati; The Contemporary Museum, Honolulu)

Selected Group Exhibitions

1978 *Income and Wealth Show.* 5 Bleecker Street, New York

Manifesto Show. 5 Bleecker Street, New York

123. Exhibition announcement for *South Bronx Hall of Fame*, Fashion Moda, Bronx, October 25, 1979.

Doctors & Dentists. 591 Broadway, New York

Dog Show. 591 Broadway, New York

1980 *Times Square Show.* New York

Fashion Moda. The New Museum of Contemporary Art, New York

Collaborative Projects Presents a Benefit Exhibition at Brooke Alexander. New York

14 New Artists. Lisson Gallery, London

1981 *Figuratively Sculpting.* P.S. 1 Museum, The Institute for Contemporary Art, Long Island City, New York

Heute: Westkunst. Cologne

Represent, Representation, Representative. Brooke Alexander, New York

The Anxious Figure. Semaphore Gallery, New York

Figures: Forms and Expressions. Albright-Knox Art Gallery, Buffalo

1982 *Face It: 10 Contemporary Artists.* Freedman Gallery, Albright College, Reading, Pennsylvania

The New Reliefs. School of Visual Arts Museum, New York

The 1982 South Bronx Show. Fashion Moda and The Bronx Council on the Arts, Bronx, New York

Painting and Sculpture Today. Indianapolis Museum of Art, Indianapolis

74th American Exhibition. The Art Institute of Chicago, Chicago

Still Modern After All These Years. The Chrysler Museum, Norfolk, Virginia

1983 *Beelden Sculpture.* Rotterdam Arts Council, Rotterdam

Urban Kisses. Institute of Contemporary Art, London

Fourth Biennial of Sydney. Sydney

New Portraits: Behind Faces. Experiencenter Gallery, Dayton Art Institute, Dayton, Ohio

Champions. Tony Shafrazi Gallery, New York

Portraits on a Human Scale. Whitney Museum of American Art, Downtown Branch, New York

1984 – A Preview. Ronald Feldman Fine Arts, Inc., in cooperation with *The Village Voice*, New York

Faces Since the 50's: A Generation of American Portraiture. Bucknell University, Center Gallery, Lewisburg, Pennsylvania

Art and Social Change, USA. Allen Memorial Art Museum, Oberlin College, Oberlin, Ohio

The Sixth Day: A Survey of Recent Developments in Figurative Sculpture. The Renaissance Society, University of Chicago, Bergman Gallery, Chicago

Exhibition: A Love Story. Just Above Midtown/ Downtown, New York

Language, Drama, Source & Vision. The New Museum of Contemporary Art, New York

State of the Art: The New Social Commentary. Barbara Gladstone Gallery, New York

New Art at the Tate Gallery, 1983. Tate Gallery, London

New Figuration in America. Milwaukee Art Museum, Milwaukee

124. John Ahearn
Freddy 1988
graphite, charcoal, and pencil on paper
12 by 9 inches (30 by 23 cm)
Courtesy Brooke Alexander, Inc.

Freddy is Rigoberto Torres' cousin.

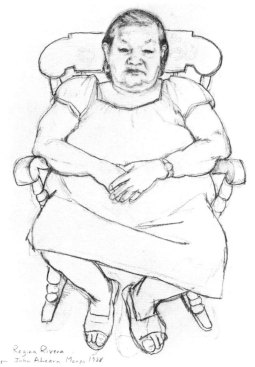

125. John Ahearn
Regina Rivera 1988
graphite, charcoal, and pencil on paper
12 by 9 inches (30 by 23 cm)
Courtesy Brooke Alexander, Inc.

Regina Rivera is Maria Fonseca's mother [fig. 102].

New York Now. Kestner-Gesellschaft, e.v. Hanover (traveled to Kunstverein, Munich; Musée Cantonal des Beaux-Arts, Lausanne; Kunstverein für die Rheinland und Westfalen, Düsseldorf)

Back to the U.S.A. Kunstmuseum, Lucerne (traveled to Rheinishes Landmuseum, Bonn; Württembergischer Kunstverein, Stuttgart)

1984 *New Portrait.* The Institute for Art & Urban Resources, Long Island City, New York

Body Politics. Tower Gallery, New York

Andrew Wyeth: Trojan Horse Modernist. Greenville County Art Museum, Greenville, South Carolina

Arte di Frontiera–New York Graffiti. Galleria d'Arte Moderna, Bologna

Humanism: An Undercurrent. University of Southern Florida, Tampa

The Human Condition: San Francisco Museum of Modern Art, Biennial III. San Francisco

New Image/Pattern and Decoration from the Morton G. Newman Collection. Kalamazoo Institute of Arts, Kalamazoo, Michigan (traveled to Madison Arts Center, Madison, Wisconsin; D. Alfred Smart Gallery, University of Chicago, Chicago; Flint Institute of Arts, Flint, Michigan; Arkansas Art Center, Little Rock; Memorial Art Gallery, University of Rochester, Rochester, New York)

Ansatzpunkte kritischer Kunst heute. Bonner Kunstverein, Bonn (traveled to Neue Gesellschaft für bildende Kunst, Berlin)

The Heroic Figure. Contemporary Arts Museum, Houston (traveled to Memphis Brooks Museum of Art, Memphis; Alexandria Museum/Visual Arts Center, Alexandria, Louisiana; Santa Barbara Museum of Art, Santa Barbara; Museo Nacional de Belas Artes, Santiago)

Content: A Contemporary Focus 1974–1984, Tenth Anniversary Exhibit. Hirshhorn Museum and Sculpture Garden, Smithsonian Institution, Washington, D.C.

1985 *Visions of Childhood: A Contemporary Iconography.* Whitney Museum of American Art, New York

1985 Biennial Exhibition. (Group Material), Whitney Museum of American Art, New York

XIIIe. Biennale de Paris. La Villette, Paris

A Summer Selection. Castelli Uptown, New York

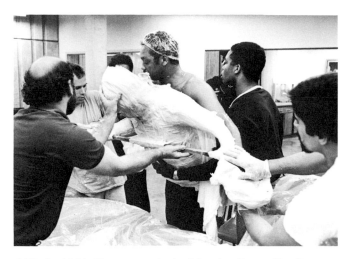

126. In 1984 Ahearn was invited by the Greenville County Museum of Art to cast local people for a series of figures, which became a permanent installation at the museum. Later, in 1987, Ahearn returned to make a cast of Jesse Jackson: [left to right] Claude Davis, Ahearn, Jesse Jackson and his son, Yssef, and Torres.

Anniottanta. Chiostra della Loggetta Lombardesca e Biblioteca Classense, Ravenna, organized by Galleria d'Arte Moderna, Bologna

Body and Soul: Aspects of Recent Figurative Sculpture. The Contemporary Arts Center, Cincinnati

Carnegie International. Carnegie Institute, Museum of Art, Pittsburgh

Site & Solutions: Recent Public Art. Freedman Gallery, Albright College, Reading, Pennsylvania, organized by University of Illinois, College of Architecture, Art & Urban Planning, Chicago

Correspondences: New York Art Now. Laforet Museum, Harajuku, Tokyo (traveled to Tochigi Prefectural Museum of Fine Arts, Utsunomiya, and Taqaki Hall Espace Media, Kobe)

1986 *Psychodrama.* Philadelphia Art Alliance, Philadelphia

Life in the Big City: Contemporary Artists, Responses to the Urban Experience. Museum of Art, Rhode Island School of Design, Providence

An American Renaissance: Painting and Sculpture Since 1940. Museum of Art, Fort Lauderdale

Norsk/Amerikansk Treffpunkt (Norwegian/American Exhibition). Stavanger Faste Galleri, Stavanger, Norway

Sculpture. Tony Shafrazi Gallery, New York

The Freedman Gallery: The First Decade. Freedman Gallery, Albright College, Reading, Pennsylvania

Selected Works from MOCA'S Lowen Collection. Mandeville Gallery, University of California, San Diego

1987 *Out of the Studio: Art with Community,* P.S. 1 Museum, The Institute for Contemporary Art, Long Island City, New York

1976–1986: Ten Years of Collecting American Art— Selections from the Edward R. Downe Collection. Wellesley College Museum, Wellesley, Massachusetts

The Eighth Annual South Bronx Show. Fashion Moda, Bronx, New York

Working Space: New Work from New York. University Art Gallery, State University of New York at Binghamton, Binghamton

Sculpture: Looking Into Three Dimensions. Anchorage Museum of History and Art, Anchorage

New, Used and Improved. Karl Bornstein Gallery, Santa Monica, California

Constitution (Group Material). Temple University, Philadelphia

Bronze, Plaster and Polyester. Moore College of Art, Philadelphia

1988 *After Street Art.* Boca Raton Museum of Art, Boca Raton, Florida

Lifelike. Lorence-Monk Gallery, New York

The World of Art Today. Milwaukee Art Museum, Milwaukee

Urban Figures. Whitney Museum of American Art at Philip Morris, New York

Democracy: Education. (Group Material), Dia Art Foundation, New York

The Art of the 1980's. Michigan State University, Kresge Art Museum, East Lansing

1989 *The Future Now.* Bass Museum of Art, Miami

Personae: Contemporary Portraiture and Self-Portraiture. Islip Art Museum, East Islip, New York

The Blues Aesthetic: Black Culture and Modernism. Washington Project for the Arts, Washington, D.C. (traveled to California Afro-American Museum, Los Angeles; Duke University Art Museum, Durham,

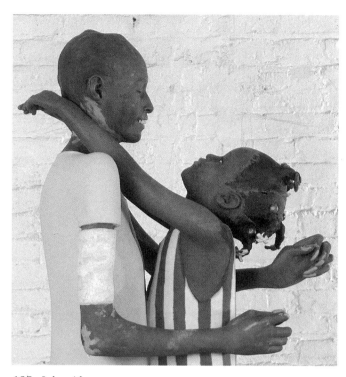

127. John Ahearn
Veronica and Her Mother [detail] 1988
Courtesy Brooke Alexander, Inc.
[fig. 99, back view]

North Carolina; Blaffer Gallery, University of Houston, Houston; The Studio Museum in Harlem, New York)

Urban Images. Madison Art Center, Madison, Wisconsin

Skulpture Teil II. Galerie Six Friedrich, Munich

1990 *The Decade Show.* Museum of Contemporary Hispanic Art, The New Museum of Contemporary Art, The Studio Museum in Harlem, New York

Inside the Beast. Charles Lucien Gallery, New York

1991 *Compassion and Protest: Recent Social and Political Art from The Eli Broad Family Foundation.* San Jose Museum of Art, San Jose, California

Hip Hop Nation. Real Art Ways, Hartford, Connecticut

Experiencing Sculpture: The Figurative Presence in America 1870-1990. The Hudson River Museum, Yonkers, New York

Devil on the Stairs: Looking Back on the Eighties. Institute of Contemporary Art, University of Pennsylvania, Philadelphia (traveling to Newport Harbor Art Museum, Newport Harbor, California)

RIGOBERTO TORRES

Born
Aguadilla, Puerto Rico, 1960

Selected Individual Exhibitions

1979 *South Bronx Hall of Fame.* Fashion Moda, Bronx, New York

1983 *John Ahearn with Rigoberto Torres: Recent Sculpture from Dawson Street.* Brooke Alexander, New York

1984 *John Ahearn with Rigoberto Torres.* Brooke Alexander, New York

1985 *John Ahearn and Rigoberto Torres – Portraits from the Bronx: Life Casts from 1979 to the Present.* The Bronx Museum of the Arts, Bronx, New York

INVESTIGATIONS: John Ahearn with Rigoberto Torres: Sculpture. Institute of Contemporary Art, University of Pennsylvania, Philadelphia

1986 *John Ahearn with Rigoberto Torres.* Brooke Alexander, New York

1989 *Art Show of Life.* Biblioteca de la Universidad Intramericana, Aguadilla, Puerto Rico

1990 *Art Show of Life.* Carcel de Aguadilla, Puerto Rico

1991 *Rigoberto Torres, Sculpture 1990–1991.* Brooke Alexander, New York

Rigoberto Torres. La Maquina Espanola, Seville, Spain

South Bronx Hall of Fame: Sculpture by John Ahearn and Rigoberto Torres. Contemporary Arts Museum, Houston (traveling to Witte de With, Rotterdam; The Contemporary Arts Center, Cincinnati; The Contemporary Museum, Honolulu)

Selected Group Exhibitions

1980 *Times Square Show.* New York

Fashion Moda. The New Museum of Contemporary Art, New York

1982 *The 1982 South Bronx Show.* Fashion Moda and The Bronx Council on the Arts, Bronx, New York

Face It: 10 Contemporary Artists. Freedman Gallery, Albright College, Reading, Pennsylvania

1983 *Art and Social Change, USA.* Allen Memorial Art Museum, Oberlin College, Oberlin, Ohio

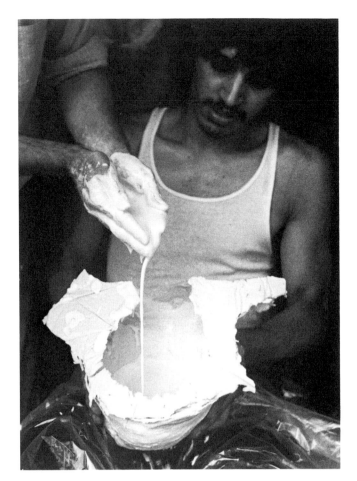

128. Torres holding mold as Ahearn pours plaster, Fashion Moda, 1979.

Language, Drama, Source & Vision. The New Museum of Contemporary Art, New York

1984 *The Human Condition: San Francisco Museum of Modern Art, Biennial III.* San Francisco

1985 *A Summer Place.* Sarah Rentschler Gallery, New York

1985 Biennial Exhibition. (Group Material), Whitney Museum of American Art, New York

Carnegie International. Carnegie Institute, Museum of Art, Pittsburgh

1986 *The Gallery Show.* Exit Art, New York

Norsk/Amerikansk Treffpunkt (Norwegian/American Exhibition). Stavanger Faste Galleri, Stavanger, Norway

1987 *Out of the Studio: Art with Community.* P.S. 1 Museum, The Institute for Contemporary Art, Long Island City, New York

The Eighth Annual South Bronx Show. Fashion Moda, Bronx, New York

Working Space: New Work from New York. University Art Gallery, State University of New York at Binghamton, Binghamton

Sculpture: Looking Into Three Dimensions. Anchorage Museum of History and Art, Anchorage

1988 *Unity: A Collaborative Process.* Goddard-Riverside Community Center, New York

Above It All. P.S. 39 Longwood Arts Project, Bronx, New York

1990 *The Decade Show.* Museum of Contemporary Hispanic Art; The New Museum of Contemporary Art; The Studio Museum in Harlem; New York

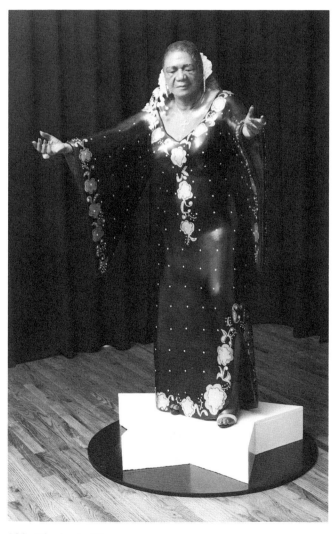

129. Rigoberto Torres
Ruth Fernandez 1991
Courtesy Brooke Alexander, Inc.
[installation view at gallery, not in exhibition]

PUBLIC PROJECTS

John Ahearn and Rigoberto Torres

1981–
1983 *Intervale Avenue Outdoor Arts Project*
Three outdoor sculpture murals funded in part by the Bronx Council of the Arts, the National Endowment for the Arts, Fashion Moda, and the Department of Housing and Urban Development:

1981–82 *We Are Family*
Intervale Avenue at Fox Street

1981–82 *"Banana Kelly" Double Dutch*
Reconstructed in 1986
Intervale Avenue at Kelly Street

1982–83 *Life on Dawson Street*
Longwood Avenue at Dawson Street

1985 *City College of the City of New York*
Eight lifecasts of students and teachers, permanently installed above the entrance to the student cafeteria, commissioned by CCNY.

1985 *Back to School*
Outdoor sculpture mural, Walton Avenue at 170th Street, Bronx, New York.

John Ahearn

1984 *Greenville County Art Museum*
Permanent installation of six life-cast portrait sculptures of Greenville residents made in cooperation with the museum, Greenville, South Carolina.

1986–
1991 *Bronx Sculpture Park*
A park plan and three freestanding, painted bronze sculptures designed by Ahearn for a traffic triangle in front of the 44th Police Precinct Building (169th Street at Jerome Avenue). Commissioned by the Percent for Art Program of the Department of Cultural Affairs, New York, and designed in conjunction with the Department of General Services, Nancy Owens, architect. Scheduled for completion fall 1991.

Bronx Sculpture Park

130 & 131. John Ahearn
Bronx Sculpture Park
This project was begun in 1986 and
is scheduled for completion fall 1991.
The site is a traffic triangle adjacent to
an elevated train trestle. Ahearn, with
architect Nancy Owens of the New York
City Department of General Services,
designed the park plan, including
terraces, seating areas, and installation
of three freestanding bronze sculptures.
169th Street at Jerome Avenue, Bronx
[left, looking west from 169th Street].

Rendering of park plan [below] and three
painted, cast bronze sculptures: *Raymond
and Toby, Daleesha,* and *Corey,* looking east
from Jerome Avenue.

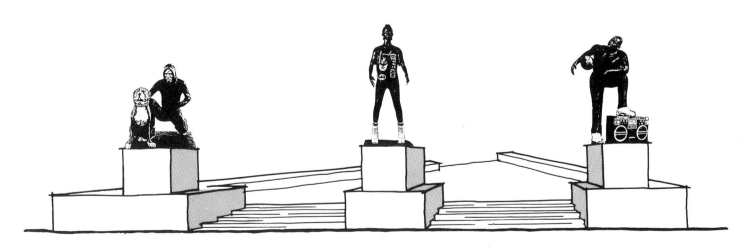

opposite:
132. John Ahearn
Corey, Bronx Sculpture Park 1991
[not in exhibition]
Epoxy paint on cast bronze
169th Street at Jerome Avenue, Bronx

Photomontage of bronze sculpture, *in
situ,* looking east from Jerome Avenue
toward 169th Street.

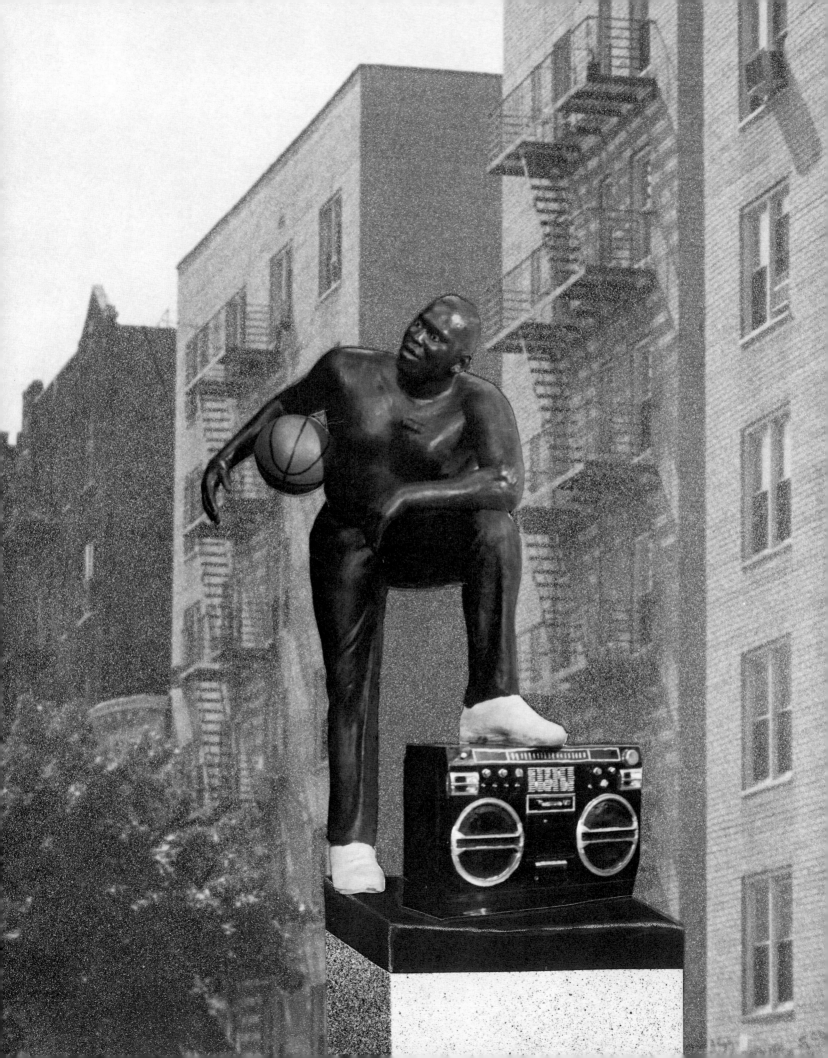

Selected Bibliography

Books

Freeman, Phyllis, Eric Himmel, Edith Paverse, and Ann Yarowski, eds. *New Art*. New York: Harry N. Abrams, Inc., 1984.

Gablik, Suzi. *Has Modernism Failed?* New York: Thames and Hudson, 1985.

Arnason, H. H. *History of Modern Art*, third edition. New York: Harry N. Abrams, Inc., 1986.

Frank, Peter, and Michael McKenzie. *New and Improved: Art for the Eighties*. New York: Abbeville Press, 1987.

Lippard, Lucy R. *Mixed Blessings: New Art in a Multi-cultural America*. New York: Pantheon Books, 1990.

Exhibition Catalogues

Events: Fashion Moda, Taller Boricura. Essays by Lynn Gumpert and Ed Jones. New York: The New Museum of Contemporary Art, 1980.

The Anxious Figure. Essay by Barry Blinderman. New York: Semaphore Gallery, 1981.

Figuratively Sculpting. Essay by Richard Flood. Long Island City, New York: P.S. 1 Museum, The Institute for Contemporary Art, 1981.

Figures: Forms and Expressions. Essays by Robert Collignon, William Currie, G. Denson, Biff Henrich, Charlotta Kotik, and Susan Krane. Buffalo: Albright-Knox Art Gallery, CEPA Gallery, HALLWALLS, 1981.

Heute: Westkunst. Essay by Kasper König. Cologne: Museen der Stadt Köln, 1981.

Face It: 10 Contemporary Artists. Essay by William Olander. Oberlin, Ohio: Ohio Foundation for the Arts, 1982.

Fourth Biennial of Sydney. Essays by William Wright and Elwyn Lynn. Sydney, Australia: 1982.

Painting and Sculpture Today. Essay by Robert Yassin. Indianapolis: Indianapolis Museum of Art, 1982.

74th American Exhibition. Essay by Anne Rorimer. Chicago: The Art Institute of Chicago, 1982.

Still Modern After All These Years. Essays by Brooks Johnson and Thomas W. Styron. Norfolk, Virginia: The Chrysler Museum, 1982.

Art & Social Change, USA. Essays by David Deitcher, Lucy R. Lippard, Jerry Kearns, William Olander, and Craig Owens. Oberlin, Ohio: Oberlin College, Allen Memorial Art Museum, 1983.

Back to the USA. Essay by Klaus Honnef. Lucerne, Switzerland: Kunstmuseum, 1983.

Beelden Sculpture. Essay by Paul Hesting. Rotterdam: Rotterdam Arts Council, 1983

Champions. Essay by Tony Shafrazi. New York: Tony Shafrazi Gallery, 1983.

Faces Since the 50's: A Generation of American Portraiture. Essay by Joseph Jacobs. Lewisburg, Pennsylvania: Center Gallery, Bucknell University, 1983.

New Art at the Tate Gallery, 1983. Essay by Michael Compton. London: Tate Gallery, 1983.

New Figuration in America. Essays by Russell Bowman, Rosalee Goldstein, Gerald Norland, and Peter Schjeldahl. Milwaukee: Milwaukee Art Museum, 1983.

New Portraits: Behind Faces. Essay by Pamela Houk. Dayton, Ohio: Experiencenter Gallery, Dayton Art Institute, 1983.

New York Now. Essay by Carl Haenlin. Hanover: Kestner-Gesellschaft, 1983.

The 1984 Show. Essays by Ronald Feldman and Carrie Rickey. New York: Ronald Feldman Fine Arts in cooperation with *The Village Voice*, 1983.

Portraits on a Human Scale. Essays by Janet Heit and Rebecca Saunders. New York: Whitney Museum of American Art, 1983.

The Sixth Day: A Survey of Recent Developments in Figurative Sculpture. Essay by Richard Flood. Chicago: The Renaissance Society, University of Chicago, Bergman Gallery, 1983.

Urban Kisses. Essay by Iwona Blazwick. London: Institute of Contemporary Art, 1983.

Andrew Wyeth: Trojan Horse Modernist. Essay by Thomas W. Styron. Greenville, North Carolina: Greenville County Art Museum, 1984.

Ansatzpunkte kritischer Kunst heute. Essays by Margaret Jochimsen, Anneli Pohlen, Barbara Straka, and Stephen Schmidt-Wulffen. Aachen, Germany: Ludwig Museum, 1984.

Arte di Frontiera – New York Graffiti. Essays by Francesca Alinovi, Robert Daolio, Marilena Pasquali, Tony Shafrazi, and Franco Solmi. Bologna, Italy: Galerie D'Arte Moderna, 1984

Content: A Contemporary Focus 1974–1984. Essays by Howard N. Fox, Miranda McClintic, and Phyllis Rosenzweig. Washington, D.C.: Hirshhorn Museum and Sculpture Garden, 1984.

The Heroic Figure. Essays by Linda L. Cathcart and Craig Owens. Houston: Contemporary Arts Museum, 1984.

The Human Condition: San Francisco Museum of Modern Art, Biennial III. Essays by Dorothy Martinson, Wolfgang Max Faust, Achille Bonito Oliva, Klaus Ottman, and Edward Keinholz. San Francisco: San Francisco Museum of Modern Art, 1984.

Anniottanta. Essay by Susanna Zanuso. Ravenna, Italy: Mazzolta, 1985.

Body and Soul: Aspects of Recent Figurative Sculpture. Essay by Sarah Rogers-Lafferty. Cincinnati: The Contemporary Arts Center, 1985.

Carnegie International. Foreword and introduction by John R. Lane and John Caldwell. Essays by Achille Bonito Oliva, Bazon Brock, Benjamin H. D. Buchloh, Germano Celant, Hal Foster, Rudi Fuchs, Johannes Gachnang, Per Kirkeby, Jannis Kounellis, Hilton Kramer, Donald B. Kuspit, Thomas McEvilley, Mark Rosenthal, Peter Schjeldahl, and Nicholas Serota. Pittsburgh: Museum of Art, Carnegie Institute, 1985.

Correspondences: New York Art Now. Essay by Nicolas A. Moufarrege. Tokyo: Tsurumoto Room Co., Ltd., 1985.

INVESTIGATIONS: John Ahearn with Rigoberto Torres: Sculpture. Essay by Paula Marincola. Philadelphia: Institute of Contemporary Art, University of Pennsylvania, 1985.

1985 Biennial Exhibition. (Group Material) New York: Whitney Museum of American Art, 1985.

Nouvelle Biennale de Paris. Essays by Georges Boudaille, Pierre Coucelles, Jean Pierre Faye, Geral Gassiot-Talabot, Alanna Heiss, Achille Bonito Oliva, Marie Louise Syring, and Tony Shafrazi. Paris: La Villette, 1985.

Sites & Solutions: Recent Public Art. Essay by Judith Tannebaum. Reading, Pennsylvania: Freedman Gallery, Albright College, 1984.

An American Renaissance: Paintings and Sculpture Since 1940. Essays by Malcolm R. Daniel, Harry F. Gaugh, Sam Hunter, Karen Koehlor, Kim Levin, Robert C. Morgan, and Richard Sarnoff. New York: Abbeville Press, 1986.

The Freedman Gallery: The First Decade. Essay by David R. Rubin. Reading, Pennsylvania: Freedman Gallery, Albright College, 1986.

Norsk/Amerikansk Treffpunkt (Norwegian/American Exhibition). Essay by Per Hovdenakk. Stavanger, Norway: Stavanger Faste Galleri, 1986.

Bronze, Plaster and Polyester. Essay by Wade Sanders. Philadelphia: Goldie Paley Gallery, Moore College of Art, 1987.

Constitution. (Group Material). Essays by Donald Kuspit, Michael Ratner, Margaret Ratner, and Honorable Bruce McM. Wright, Justice of Supreme Court, State of New York. Philadelphia: The Temple Gallery, Temple University, 1987.

1976–1986: Ten Years of Collecting Contemporary American Art—Selections from the Edward R. Downe Collection. Essays by Patterson Sims and Suzanne Stroh. Wellesley, Massachusetts: Wellesley College Museum, 1987.

Sculpture: Looking into Three Dimensions. Essay by Ann Fitzgibbon. Anchorage: Anchorage Museum of History and Art, 1987.

After Street Art. Essay by Allan Schwartzman. Boca Raton, Florida: Boca Raton Museum of Art, 1988.

The World of Art Today. Essay by Russell Bowman. Milwaukee: Milwaukee Art Museum, 1988.

The Blues Aesthetic: Black Culture and Modernism. Essays by Dwight D. Andrews, Sherrill Berryman-Miller, John Cephas, Richard J. Powell, Eleanor W. Traylor, and John Michael Viach. Washington, D.C.: Washington Project for the Arts, 1989.

The Decade Show. Essays by Julia P. Herzberg, Sharon F. Patton, Gary Sangster, and Laura Trippi. New York: The Museum of Hispanic Art, The New Museum of Contemporary Art, The Studio Museum in Harlem, 1990.

John Ahearn. Interview with Deborah Emont Scott. Kansas City, Missouri: The Nelson-Atkins Museum, 1990.

South Bronx Hall of Fame: Sculpture by John Ahearn and Rigoberto Torres. Essays by Richard Goldstein, Michael Ventura, and Marilyn A. Zeitlin. Houston: Contemporary Arts Museum, 1991.

Periodicals

Robinson, Walter. "Art Strategies: The 80's." *Addix Magazine*, 1979.

Robinson, Walter. "John Ahearn at Fashion Moda." *Art in America*, 18, no. 1 (January 1980): 108.

Rickey, Carrie. "John Ahearn, New Museum Windows." *Artforum*, 18, no. 7 (March 1980): 75.

Lippard, Lucy R. "Real Estate and Real Art." *Seven Days* (April 1980): 32–34.

Goldstein, Richard. "First Radical Art Show." *The Village Voice*, 16 June 1980.

Deitch, Jeffrey. "Report from Times Square." *Art in America*, 68, no. 7 (September 1980): 58.

Levin, Kim. "Times Square Show." *Arts Magazine*, 55, no. 1 (September 1980): 87–89.

Lippard, Lucy R. "Sex and Death and Schock and Schlock: A Long Review of the Times Square Show." *Artforum*, 19, no. 2 (October 1980): 50–55.

Zimmer, William. "Fashion Moda Reviews." *SoHo Weekly News*, 11 October 1980.

Armstrong, Richard. "Cologne 'Heute' Westkunst." *Artforum*, 20, no. 1 (September 1981): 85–86.

Schjeldahl, Peter. "Anxiety as a Rallying Crowd." *The Village Voice*, 16 September 1981.

Ammann, Jean-Cristophe. "Westkunst in Cologne." *FlashArt*, no. 104 (October/November 1981): 51.

Larson, Kay. "Sculpting Figuratively." *New York Magazine* (November 1981): 120–22.

Ratcliff, Carter. "The Distractions of Theme." *Art in America*, 69, no. 9 (November 1981): 19–23.

Ricard, Rene. "The Radiant Child." *Artforum*, 20, no. 3 (November 1981): 43.

Siegal, Jeanne. "New York, Figuratively Sculpting, P.S. 1." *Art Express* (March/April 1982): 64.

Siegal, Jeanne. "The New Reliefs." *Arts Magazine*, 56, no. 8 (April 1982): 143–44.

Von Arnheim, G. "Atelier in den slums." *Das Art* (April 1982): 88–89.

Lippard, Lucy R. "Art: Revolting Issues." *The Village Voice*, 27 July 1982.

Goldstein, Richard. "Artbeat: Something There is That Loves a Wall." *The Village Voice*, 3 August 1982.

Kirshner, Judith Russi. "Chicago: 74th American Exhibition, Art Institute Chicago." *Artforum*, 21 (October 1982): 75.

Brasz, Marc. "'It's Like a Jungle': Political Art of the 80s." *Arts Quarterly* (New Orleans Museum of Art), 4 (October–December 1982): 21–27.

de Ak, Edit. "John Ahearn, 'We Are Family' 877 Intervale Avenue. The Bronx." *Artforum*, 21, no. 3 (November 1982): 73–74.

Hatton, Brian. "Urban Kisses: New York at the I.C.A." *Artscribe* (December 1982).

Dimitrijevic, Nena. "'Urban Kisses,' Institute of Contemporary Arts, London." *FlashArt*, no. 110 (January 1983): 66.

Goldstein, Richard. "Heroes and Villains in the Arts." *The Village Voice*, 4 January 1983.

Howe, Katherine. "John Ahearn with Rigoberto Torres at Brooke Alexander." *Images and Issues* (January/February 1983).

Honnef, Klaus. "Tagebuch einer Dienstreise." *Kunstforum International* (May 1983).

Artner, Alan. "The Return of the Human Touch: Figurative Sculpture is Really Back in Vogue." *The Chicago Tribune*, 15 May 1983.

Glatt, Cara. "Sculptors Look at Human Form." *The Chicago Herald*, 25 May 1983.

Moser, Charlotte. "Renaissance Show Surveys Ten Years of Using Human Form in Sculpture." *Chicago Sun Times, Show Section*, 29 May 1983: 6.

Glueck, Grace. "John Ahearn and Rigoberto Torres." *The New York Times*, 1 July 1983.

Murray, Megan. "Casting Director." *New York Daily News, Sunday News Magazine*, 3 July 1983.

Goldstein, Richard. "Artbeat: The Politics of Culture." *The Village Voice*, 26 July 1983.

Shepard, Joan. "Artistic 'Immortality' for Ordinary People." *Metro: Daily News*, 30 July 1983: 1.

Larson, Kay. "John Ahearn." *New York Magazine* (August 1983).

Storr, Robert. "John Ahearn and Rigoberto Torres at Brooke Alexander." *Art in America*, 71, no. 10 (November 1983): 226–27.

Apuleo, Vito. "New York Graffiti a Bologna: Nel Luna Park della Memoria." *Il Messaggerio* (March 1984).

Brown, Kenyon. "Role of Artists: Community Outreach." *Public Art Fund Newsletter*, Spring 1984.

Levin, Kim. "Body and Politic." *The Village Voice*, 9 May 1984.

Becker, Robert. "Sculptural Visions." *Interview* (June 1984): 77.

Baudrillard, Jean. "Astral America." *Artforum*, 23, no. 1 (September 1984): 72.

Wolff, Theodore F. "The Home Forum: Neighbors at Art." *The Christian Science Monitor*, 13 September 1984: 34.

Smith, Roberta. "Endless Meaning at the Hirshhorn." *Artforum*, 23, no. 8 (April 1985): 81–85.

Wilson, William. "In Search of the Heroic." *Los Angeles Times, Calendar*, 28 April 1985.

Dillis, Keith. "Contemporary Figures and Questions." *Artweek*, 16, no. 20 (18 May 1985): 1.

Schwartzman, Allan. "Street Art." *New Look* (September 1985).

McGill, Douglas. "Art People: Landscapes of Body." *The New York Times*, 18 October 1985.

Southard, Edna Carter. "Body and Soul." *Dialogue* (November/ December 1985): 37–38.

Wolff, Theodore F. "In Houston: A Show That's Not Heroic—But Still Educational." *The Christian Science Monitor*, 19 November 1985.

Larson, Kay. "Body and Soul." *New York Magazine* (10 February 1986).

Hirschland, Roger B. "Plaster Look-Alikes." *National Geographic World* (March 1986): 10–13.

Nadelman, Cynthia. "A Star Struck Carnegie International." *ARTnews*, 85, no. 3 (March 1986): 116–17.

Stavitsky, Gail. "The 1985 Carnegie International." *Arts Magazine*, 60, no. 7 (March 1986): 58–59.

Mahoney, R. "Group Show, Tony Shafrazi Gallery; New York Exhibit." *Arts Magazine*, 60, no. 8 (April 1986): 137.

Van der Marck, Jan. "Report from Pittsburgh: The Triennial Revived." *Art in America*, 74, no. 5 (May 1986): 49.

Brenson, Michael. "A Bountiful Season in Outdoor Sculpture Reveals Glimmers of New Sensibility." *The New York Times*, 18 July 1986.

Larson, Kay. "The Real, the Irreal and the Ugly: John Ahearn." *New York Magazine* (November 1986).

McCormick, Carlo. "Soul Men." *Paper* (November 1986).

Brenson, Michael. "John Ahearn." *The New York Times*, 7 November 1986.

Hess, Elizabeth. "John Ahearn." *The Village Voice*, 25 November 1986.

Levy, Ellen. "A Community Commitment." *Public Art Fund Newsletter*, Winter 1987.

Singer, Karen. "Successes and Controversies Highlight Public Art Conference." *Citysites* (Winter 1987).

Bass, Ruth. "New York? New Work!" *Art Talk* (January 1987).

McCormick, Carlo. "John Ahearn with Rigoberto Torres." *Artforum*, 25 (February 1987): 115–16.

Smith, Paul. "John Ahearn with Rigoberto Torres at Brooke Alexander." *Art in America*, 75, no. 6 (February 1987): 153.

Levin, Kim. "Art with Community." *The Village Voice*, 25 February 1987.

Ingram, Jan. "Exhibit Offers Introduction to Many Faces of Sculpture." *Anchorage Daily News*, 12 July 1987.

Sozanski, Edward. "The Works of a Dozen Sculptors Help Shape a Revival of Casting." *The Philadelphia Inquirer*, 12 November 1987.

McKinney, Debbie. "Young Dimensions." *Anchorage Daily News*, 7 April 1988.

Hess, Elizabeth. "Just Desserts?" *The Village Voice*, 7 June 1988.

Glueck, Grace. "An Immovable Feast: Murals in the City." *The New York Times*, 22 July 1988.

Engler, Brigitte. "Behind the Mask." *Paper* (November 1988).

McCall, Ella. "I Tell Homeless Kids, 'Love You Baby.'" *The New York Times*, 1 November 1988.

Hess, Elizabeth. "Working the Street." *The Village Voice*, 29 November 1988.

Morgan, Robert C. "John Ahearn." *Arts Magazine*, 63, no. 6 (February 1989): 99–100.

Muchnic, Suzanne. "Family Puts Art on a Firm Foundation." *Los Angeles Times*, 5 December 1989.

LeComte, Richard. "Sculptor Finds Art in His Neighbors, Culture." *Lawrence Journal-World* (Kansas), 15 January 1990.

Sugg, Rich. "Wall Figures." *The Kansas City Times*, 17 January 1990.

Hoffmann, Donald. "Images of Life." *Kansas City Star*, 28 January 1990.

Lipson, Karin. "Showing Their Stuff." *Newsday* (September 1990).

Ahearn, Charlie. "Inside Story of John Ahearn's 'South Bronx Hall of Fame.'" *Paper* (March 1991).

Barnett, Catherine. "The Sculptor's Models Are the Stars." *New York Newsday* (6 March 1991).

Brenson, Michael. "Sculpture Borne by the Earth and Lighted by the Sky." *The New York Times*, 8 March 1991.

"John Ahearn/Rigoberto Torres." *The New Yorker* (1 April 1991).

Castano, Javier. "Arte de la Communidad y para la Communidad." *El Diario* (18 April 1991).

Photography Sources/Figure Numbers

John Ahearn, Bronx; 13, 37, 55, 73, 96, 97, 103, 105, 107, 108, 123, 130–132

Brooke Alexander, Inc., New York; 39, 69, 91, 93, 94, 102, 111

The Eli Broad Family Foundation, Santa Monica, California; 76

The Brooklyn Museum; 133

Martha Cooper, New York; frontispiece, 32, 38, 45, 50, 65, 74

D. James Dee, New York; 14–19, 21–23, 25–29, 49, 57, 61, 66, 70, 75, 100, 104, 109, 110, 112–116, 117–122, 129

Ivan Dalla Tana, New York; cover, back cover, 1, 36, 44, 47, 52, 56, 63, 64, 67, 71, 72, 78–90, 92, 95, 98, 99, 101, 106, 124, 125, 127

eeva-inkeri, New York; 46

Lisa Kahane, New York; 35, 42, 43

Christof Kohlhofer, Hollywood; 2–11, 34, 128

Susan and Lewis Manilow, Chicago; 53

Ari Marcopolous, New York; 20, 77

Jeannette Montgomery-Barron, New York; 58–60

Eric Pollitzer, Hempstead, New York; 48

William Potthast, Winter Haven, Florida; 33, 54

Ted Ramsaur, Greenville, South Carolina; 126

Christy Rupp, New York; 31

Squidds & Nunns, Los Angeles; 41

Wolfgang Staehle, New York; 24

Nancy Stout, New York; 30

Rigoberto Torres, Bronx; 51

Robert Wedemeir, Los Angeles; 12, 40, 62, 68

Colophon

Design: Don Quaintance, Public Address Design, Houston

Typography: Franklin Gothic Condensed and New Baskerville set by TexSource, Houston

Color separations/halftones: Color Separations, Inc., Houston

Papers: Text – Potlatch Vintage Velvet Cover – Champion Kromekote 2000

Printing: Riverside Press, Houston

Binding: Roswell Bookbinders, Phoenix

Four thousand copies published by Contemporary Arts Museum, Houston, August 1991. Seven-hundred-and-fifty copies of this edition are supplemented by a Dutch translation of the foreword and acknowledgments, and the three essays.

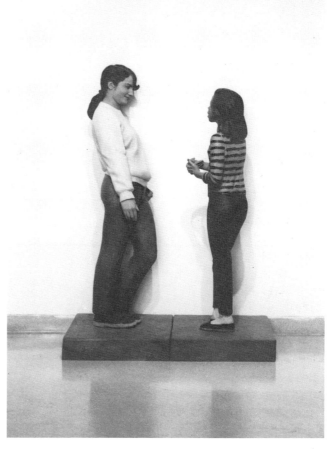

133. John Ahearn
Evie and Hazel in Conversation 1986
Collection The Brooklyn Museum 87.194.2a-b
Gift of Cheryl and Henry Welt in memory of Abraham Joseph Welt

Hazel Santiago is the model being cast in the photo on the back cover.